IMAGES
of America

MARYSVILLE'S
CHINATOWN

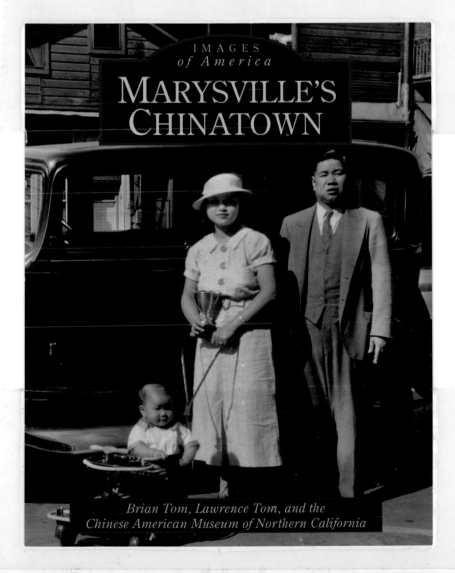

IMAGES
of America

MARYSVILLE'S
CHINATOWN

Brian Tom, Lawrence Tom, and the
Chinese American Museum of Northern California

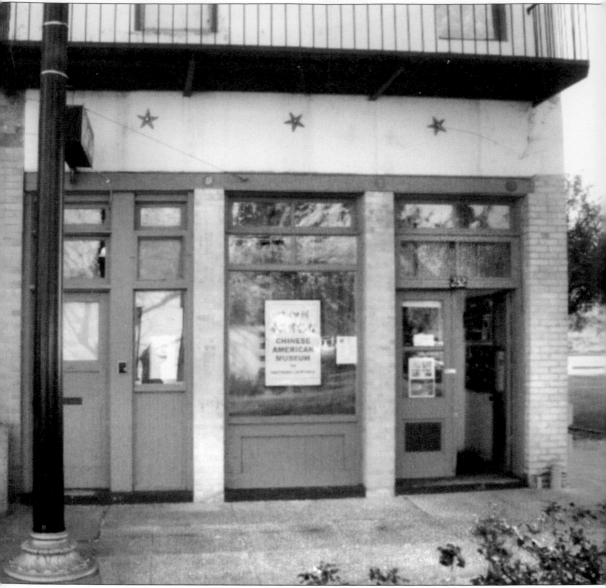

The Chinese American Museum of Northern California is pictured above. Opened during the Bok Kai Festival in 2007, the museum is dedicated to preserving and interpreting the history of the Chinese in America. The museum building is a Gold Rush building constructed in 1858. It is located on the corner of First and C Streets in the heart of the old Marysville Chinatown, the same intersection where bombs have been fired every Bomb Day for over 100 years. (Courtesy Brian Tom.)

ON THE COVER: The cover is a picture of Arthur M. Tom Sr. and Betty Tom, taken in 1936, standing in front of their car in the Marysville Chinatown. The baby is Arthur M. Tom Jr., who just won a baby contest held during the Bok Kai Festival that year. (Courtesy Lawrence Tom.)

IMAGES
of America

MARYSVILLE'S
CHINATOWN

Brian Tom, Lawrence Tom, and the
Chinese American Museum of Northern California

ARCADIA
PUBLISHING

Published by Arcadia Publishing
Charleston SC, Chicago IL, Portsmouth NH, San Francisco CA

Printed in the United States of America

Library of Congress Catalog Card Number: 2008930816

For all general information contact Arcadia Publishing at:
Telephone 843-853-2070
Fax 843-853-0044
E-mail sales@arcadiapublishing.com
For customer service and orders:
Toll-Free 1-888-313-2665

Visit us on the Internet at www.arcadiapublishing.com

This book is dedicated to our parents, Arthur M. Tom Sr. and Betty Tom, who believed in an America that would live up to its promise of equality for all and a China that would regain its former glory. Arthur M. Tom Sr. and Betty Tom are pictured at the Pago Pago restaurant in the 1940s. The restaurant was owned by a family friend, and the Toms often went there in the evening to relax after a long day. (Courtesy Brian Tom.)

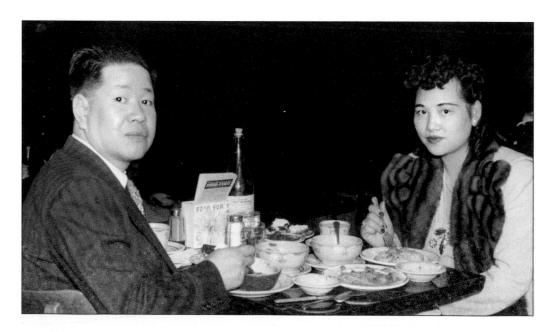

CONTENTS

ACKNOWLEDGMENTS

We would like to thank the members of the pioneer Chinese families of Marysville who so graciously gave us permission to use their family photographs and histories. Among the family members who deserve special mention are Bertha Waugh Chan, Doreen Foo Croft, Virginia Ong Gee, Leonard Hom, Stanley Hom, Rogena Hoyer, Alisa Kim, Frank Kim, Jack Kim, Gene Sing Lim, Bing Ong, Arthur M. Tom Jr., David Wing, and Brenda Lee Wong.

Loren McCrory, director of the Yuba County Library, David Dewey of the city of Oroville, and Bill Jones of the California State University, Chico, Meriam Library also deserve our gratitude for their assistance. Our brother, Wilbur Tom, helped with the photographs in the museum. A special thanks to Kara and James Davis, owners of Americus Books in Marysville for their support, encouragement, and their dedication to local history. Thanks also to our editor at Arcadia Publishing, Kelly Reed, for her much appreciated advice, guidance, and suggestions. The pioneering work of Him Mark Lai in Chinese American history has been of enormous help.

Many of the photographs came from our cousin Gordon Tom, who has been a photographer for over 50 years. In addition, he preserved many of the photographs taken by our late uncle Hom S. Suey, a professional photographer who took pictures in the 1920s and 1930s. Gordon has been an immense help in putting this book together. He has the distinction of being the last Tom in Marysville and has been the tour guide for the Bok Kai Temple for over 40 years.

Brian would like to thank Charlotte Cook, who read and commented on the text. His daughter Katherine Tom also read the complete text and made suggestions.

INTRODUCTION

The Marysville Chinatown is the last Chinatown of Gold Rush California. It still has an active temple, three Chinese associations, and the old Chinese school building. And every year, as they have done for the past 150 years, they still fire the "bombs" on Bomb Day (Bok Kai Festival), the second day of the second month of the lunar year.

The Marysville Chinatown has survived the horrors of the anti-Chinese movement led by racists who were determined that "the Chinese must go." It has survived the official reign of terror, when the full weight of federal, state, and local governments was used to exclude and expel the Chinese from America. It has survived even the effects of a diminishing population base as their sons and daughters left town to seek better opportunities in the urban centers of the state.

The Marysville Chinatown has survived because the inhabitants, descendants of the original Chinese pioneers in California, will not give up. They sense the historical importance of their home and understand that if their Chinatown disappears, the last link to the beginning of Asian history in America will be lost forever.

So every year, the Chinese of Marysville unpack the "Gum Lung" dragon, make the bombs for Bomb Day, sweep out the temple, and prepare to celebrate another year in Old Gold Mountain.

THE CHINA BACKGROUND. In 1850, when the Chinese pioneers helped build Marysville, China produced 33 percent of the world's gross national product. But China was a country going through immense change. Its productive power would soon diminish as westerners sought the riches of China. England was a leader in that effort. It started the Opium Wars in 1839 in the name of "free trade" so English merchants could sell the deadly drug in China.

The Cantonese, who were almost all of the early Chinese pioneers that came to America, have a history of being independent from the central government because of their distance from Beijing, the nation's capital. "The mountain is high, and the emperor is far away" is a favorite proverb. They think of themselves as the true Chinese, living far to the south, away from the barbarian invaders from the north. As the true Chinese, it would be up to the Cantonese to save the nation when the nation was in danger.

Canton (Guangzhou), the capital of Guangdong province, is a major seaport and the political and commercial center of the Cantonese people. For 80 years before the first Opium War, Canton was the only Chinese port open to trade with the West. As trade with the West grew, Guangdong began to develop the infrastructure to handle the increased trade. This trade along with a highly developed agricultural base and light industry made Guangdong one of the richest provinces in China.

There is a special place in Guangdong called the "Four Counties" or Siyi (Szeyup), which include Taishan (Toishan), Kaiping (Hoiping), Xinwui (Sunwui), and Enping (Yanping). Eighty percent of the early Chinese pioneers came from these four counties, half from Taishan alone. The land where the Siyi people live is in a beautiful part of Guangdong with rich soil, abundant rice paddies, and productive orchards. Because of the land and climate, the local farmers are able to harvest two or three crops of rice a year. The variety of fruits, melons, and vegetables grown there is a source of pride for the local residents.

Like all Cantonese, the Siyi people are well known for being confident, adventurous, and open to new ideas. Their stubbornness is legendary. They refuse to give up even when a situation appears

7

hopeless. This stubbornness is grounded in their history. When the Mongols invaded China, the Song dynasty armies retreated to the south. After a decade of fighting, the Song Dynasty made a last stand in Siyi. Knowing the end was near, the Song dynasty prime minister Lu Xiufu strapped the Song boy emperor to his back and leaped into the South China Sea near the present-day Taishan Xinwui county line. With the death of the emperor, the Song forces disbanded. Many stayed in Siyi. Even today, Siyi families with the surnames Chew, Jew, and Jue claim descent from the Song royal line. "Never surrender" became part of the history of the Siyi people.

History was to repeat itself when more barbarians, this time the Manchus, invaded China in 1644. Again the ruling Ming Dynasty retreated to the south. Again the resistance was most fierce in Guangdong, with major battles taking place in Taishan. After defeating the Ming Dynasty, the Manchus established the Qing Dynasty, which was still in power in 1850 when the Cantonese first started coming to America. Knowing the rebellious nature of the Cantonese people, the Manchus imposed political restrictions against them. The Manchus knew that when the revolution came, it would be led by the Cantonese people.

THE GOLD RUSH AND THE COMING OF THE CHINESE PIONEERS. The California Gold Rush in the middle of the 19th century was an important event in world history. It marked the beginning of globalization, when transportation and communications had evolved to such a state that one event could impact the whole globe. People from all over the world joined in the California Gold Rush. Americans from the eastern part of the United States came. The British, French, Spanish, Swiss, and Germans joined in. From the southern hemisphere came Chileans, Peruvians, and Australians. Sonorans and Hawaiians took part. From the largest continent of all, Asia, only the Chinese came, and of the Chinese, only the adventuresome Cantonese.

The gold discovered in California was immense; equally important, the gold was "free for the taking." In Guangdong, a circular listed the attractions of California: "[The Americans] want the Chinese to come. . . . It is a nice country, without mandarins or soldiers." Finally there was a country where the Cantonese would not be persecuted by mandarin officials. It didn't take long for them to make up their mind to join the greatest gold rush in the world. The early Chinese pioneers to America were not disappointed. California during the Gold Rush was a free and surprisingly egalitarian society. Everyone was a pioneer with the pioneer's spirit of treating people by their contribution to building a new society.

CHINESE PIONEERS IN AMERICA. When the Cantonese came to California starting in 1849, they encountered a land such as they had never imagined before. They had come from a place that had been settled for over 1,000 years; every rock had a name, every tree an owner. Suddenly they were in a land where there seemed to be no boundaries. Gold was free for the taking. But it wasn't only the gold. The wealth of the long California coastline had been untapped; the forest uncut and the rich soil of the central valley undisturbed. Everywhere they looked there was opportunity. They quickly went exploring, first in the gold country of California, from the southern mines to the northern mines, then later to the Trinity Mountains. They opened restaurants from one end of the state to the other. Still later they expanded their reach to Oregon, Idaho, Washington, Nevada, Montana, Wyoming, Arizona, and New Mexico. Pushing farther, they were soon in Canada and Alaska.

Prevented by the Manchu overlords from organizing political groups, the Cantonese in California formed tongs. Each member of the tongs swore an oath to "Fan Qing, Fu Ming"—"Overthrow the Qing, Restore the Ming." It would not be long before the worse fears of the Manchu despots were realized.

In the gold fields, the Chinese soon made their presence known. Their food and medicine were superior compared to that of other miners. Boiling water for tea kept them healthier than many who drank water directly from creeks and streams. And their clan and tong affiliations meant they could form large partnerships of more than 100 men to mine the more difficult sites that other miners could not handle. In time, the Chinese miners became a major force in the mining

camps of California. In 1860, a full 25 percent of the miners in the Golden State were Chinese. By 1870, more than half the miners in California were Chinese.

In the first two decades of their coming to America, the Chinese built over 30 Chinatowns. More than 90 percent of the Chinese in the state lived in these small-town Chinatowns. In every Chinatown, they built temples, introducing Buddhism and Taoism to North America. They brought their skills in farming, started the fishing industry, and opened restaurants; they had made a home for themselves in the Golden State.

THE ANTI-CHINESE MOVEMENT AND STEREOTYPICAL HISTORY. The golden age in California for the Chinese would not last. The transcontinental railroad, which the Chinese helped build, would prove to be their downfall. Once it took a pioneer to make the journey to California, but with the completion of the railroad, the masses could come with just a ticket and a week's time. California was soon flooded with immigrants, many newly arrived from Europe.

One of the myths about race relations in California has been that there was a unified "white" race that started the anti-Chinese movement. But the truth was more complex. There have always been two European American positions on the Chinese question: the "pioneer" position, which was pro-Chinese, and the "racist" position, which was anti-Chinese. The pro-Chinese position was taken by businessmen, clergy, diplomats, manufacturers, and those who believed in equality. The anti-Chinese position was taken by the working class, mainly those who were newly arrived from Europe, public officials who depended on the working-class vote, and newspapers that voiced the position of the working class.

America is a country founded on the ideal of equality and freedom for all. Reaching that ideal has not been easy. The history of America has been one of integrating the "lower-class" whites into the "upper-class" whites. This was America, the melting pot. In 1870, the newly arrived Irish were in the lower class. Their leaders knew that in order to become accepted by the upper-class whites they had to play the "race card." Led by Denis Kearny, an Irish immigrant, they played the race card masterfully.

It was during the anti-Chinese movement, started in the 1870s and continuing for half a century, that the stereotype against the Chinese was created. The movement was ostensibly based on competition for jobs, but in fact, it was based on an appeal to race animosity and the creation of a racial stereotype that would allow the lower-class whites to gain the acceptance of upper-class whites. The stereotype the racists created depicted the Chinese as semi-slaves, drug fiends, and misogynists. They were of the coolie class that came from the poorest part of China. They were only interested in working for low wages and saving enough so they could return to China. They could never assimilate into American society. The racists created this stereotype so they could convince the general population to discriminate against the Chinese. Against all evidence to the contrary, it worked. In 1882, the Chinese Exclusion Act was passed. A part of the American dream died that year; the dream that America was a freedom-loving land that welcomed everyone.

The Marysville Chinatown was the commercial, social, and political center for the smaller Chinatowns that surrounded it. When the anti-Chinese movement erupted, the smaller Chinatowns were attacked by 19th-century terrorists led by groups like the Order of Caucasians. Chico, Red Bluff, Oroville, Redding, and Wheatland, up and down the northern valley, killings and burnings were visited upon the Chinese. The Marysville Chinatown, founded by tough and hardy miners, became a place of refuge. The Chinese knew they had to make a stand there. If the racists were not stopped in Marysville, the next stop would be the port of San Francisco for the trip back to China. The Chinese in Marysville did not falter. They welcomed their compatriots from the smaller Chinatowns fleeing from murder and arson. They armed themselves, preparing for a last stand, should one become necessary. They remember the words of their ancestors: "Never surrender to the barbarians."

BUILDING A CHINESE AMERICA. The passage of the Chinese Exclusion Act was a major blow against the Chinese in America. But they did not give up their dream that the greatest democracy

in the world had a place for them. The Chinese fought back in the courts, with an undying belief in the American justice system. They engaged in civil disobedience. When Congress passed the Geary Act in 1892, forcing every Chinese person in America, citizen or not, to carry an identification card, almost every one of the 100,000 Chinese in America refused to obey the law. As part of the Chinese defiance of the Geary Act, in 1894, for the first time in a Bok Kai festival, the Chinese in Marysville refused to fly the American flag.

Chinese Americans believed they were entitled to be part of the American dream, so they created the paper son plan, a method of claiming entry to America through false documentation that ensured the racist goal of excluding and expelling them from America would not succeed. For a time, it seemed that the racists had won. Decade after decade after the passage of the Chinese Exclusion Act, the Chinese population in America decreased so that by 1920 only 60,000 remained. The Chinese acquired the distinction of being the only immigrant group in America to see their population dwindle. Without the paper son plan, in another few decades, the Chinese in America would have vanished.

One of the goals of the anti-Chinese movement was to force the Chinese to return to China by depriving them of a way to make a living. Racists passed laws that restricted the work the Chinese could do. One of the ironies of the anti-Chinese movement was that proponents said the Chinese were taking work away from European American workers. But in fact, the exact opposite was taking place. The Chinese had arrived in California first; it was their jobs that were being taken away by the newly arrived immigrants to California. As the Chinese were forced out of industry after industry, they adjusted. They opened restaurants, laundries, and herb shops, all small independent businesses that did not rely on being hired by the government or European American businesses. Slowly the Chinese built a foundation for survival in a hostile land.

One area where Chinese Americans excelled was in education. Starting around the dawn of the 20th century, they began entering the best universities on the West Coast. They did so even though their high school teachers told them it would be a waste of time as no one would hire them when they graduated. For years, even into the 1930s, no jobs were available to Chinese American college graduates. A graduate with a doctorate from MIT ended up working in a San Francisco Chinese furniture store. Many graduate engineers worked in restaurants. Only with the start of World War II did the race barrier start to fall. For the first time, Chinese American college graduates could apply for jobs with the state and federal governments. Then in the 1950s, private employers started to hire Chinese Americans. Some areas of employment took longer. It wasn't until the mid-1970s that a major law firm in San Francisco hired a Chinese American attorney.

During this period, when they were fighting for their survival in America, they never forgot their homeland. When the reformers Kang Youwei and Liang Qichiao came to America in the early 1900s to learn about American democracy and raise funds, they were given a warm welcome and much-needed financial support. When reform of the imperial system no longer seemed possible, the revolutionary Sun Yat-sen came to appeal for the help of Chinese Americans. At every stage during China's turbulent modern history, Chinese Americans sent money and people back to help China develop into a new nation.

Racism Defeated; A New Chinese America. With the entry of the United States into World War II, China and America became allies in the fight against Fascism. Chinese Americans volunteered in large numbers to serve in the armed forces of the United States. Within two years, in 1943, America repealed the Chinese Exclusion Act and Chinese immigrants could become naturalized citizens. The racist idea that America had no place for the Chinese had been rejected.

Though the glass ceiling exists in many aspects of American society, the efforts of the Chinese American pioneers have led to a better life for all Chinese and Asians in America. The ideal these pioneers believed in—that America, the greatest democracy in the world, had a place for the Chinese—is starting to be realized.

–By Brian Tom

One

THE CHINA BACKGROUND

In the middle of the 19th century, China was still one of the richest countries on earth. But that would soon change. England started the Opium Wars so they could trade the opium they grew in its colony of India for the luxury goods of China. Flooding China with the deadly drug was a major factor leading to an impoverished China toward the end of the 19th century.

China in 1850 was ruled by the Qing (Manchu) Dynasty and had been for over 200 years. When the Manchus invaded China from the north, they drove the Ming Dynasty armies south, until they finally reached Guangdong, the home of the Cantonese people. The Cantonese people put up a fierce resistance. In the end, they were no match for the barbarians of the north. The Qing Dynasty, recognizing that the Cantonese would try to form a resistance movement overseas, passed a law to prevent them from going abroad.

For 200 years, the Cantonese dreamed of the day when the mandate of heaven would pass from the Qing Dynasty. When the Qing was defeated in the Opium Wars, the Cantonese saw it as a sign that the time was near. When the Cantonese learned in 1849 about the Gold Rush in California, they saw this as another sign: gold, free for the taking, in a country that valued political and religious freedom. It would be the perfect place to organize people and raise money for the overthrow of the Qing Dynasty.

The Siyi (Szeyup or "Four Counties") part of Guangdong is an important historical part of China including Taishan (Toishan), Xinwui (Sunwui), Kaiping (Hoiping), and Enping (Yanping). It is here that important battles were fought when the Song and Ming Dynasties fell first to the Mongols and later to the Manchus. The Siyi people have always been aware of the role they have played in the history of the Chinese nation. More than any other area, they sensed the need for the overthrow of the Qing Dynasty. More than 80 percent of all the Chinese pioneers to America came from these four counties.

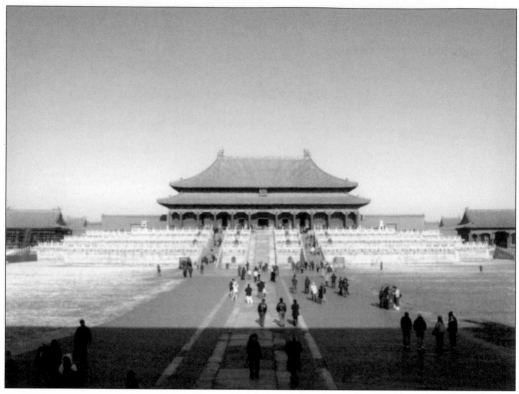

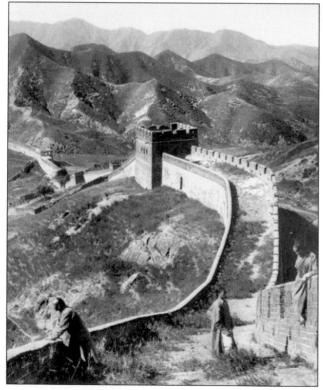

The Forbidden City in Beijing was the Chinese Imperial Palace from the early 15th century until the fall of the Qing Dynasty in 1911. It is the world's largest surviving palace complex. (Courtesy Chinese American Museum of Northern California.)

The Great Wall was a symbol of China's strength and unity. It was rebuilt during the Ming Dynasty but was ineffective in stopping the Manchu invasion in 1644. (Courtesy Chinese American Museum of Northern California.)

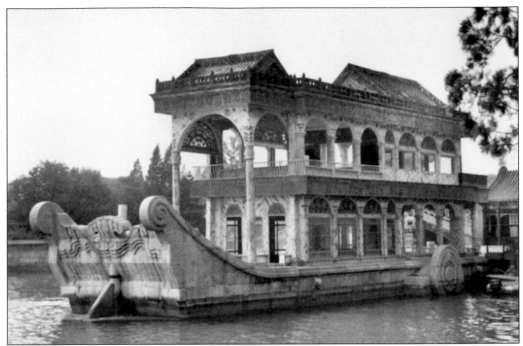

In 1893, money set aside to modernize the Chinese navy was diverted to restore the Marble Boat at the Summer Palace, another indication that the Qing Dynasty was unable to respond effectively to the challenge from the West. (Courtesy Chinese American Museum of Northern California.)

Guangzhou was always considered one of the academic and intellectual centers of China. This is a picture taken in 1873 of the cubicles in Guangzhou where the imperial examinations were given. (Courtesy Chinese American Museum of Northern California.)

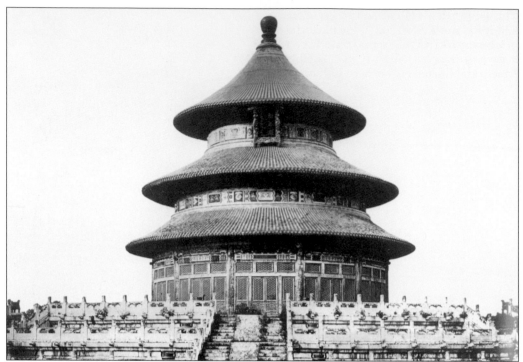

The Temple of Heaven, built in the 15th century, symbolized the relationship between heaven and earth. By the mid-19th century, when this photograph was taken, the Qing Dynasty was unable to maintain it properly. (Courtesy Chinese American Museum of Northern California.)

Pictured is a traditional Chinese painting by Wang Shih-min, painted in the 17th century. (Courtesy Smithsonian Institute.)

This self-portrait by Ren Xiong, painted in the mid-1850s, was a reflection of the rapid changes in Chinese society during that time. Even today, it seems strikingly modern. (Courtesy Chinese American Museum of Northern California.)

Shangchuan Island, a part of Taishan County, was one of the first places westerners landed when they came to China in the 16th century. St. Francis Xavier died there in 1552. This memorial chapel was built in his name in 1869. (Courtesy Chinese American Museum of Northern California.)

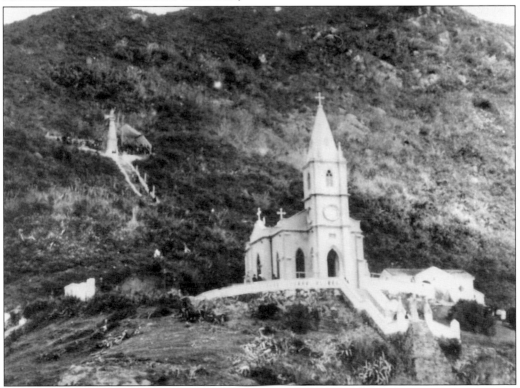

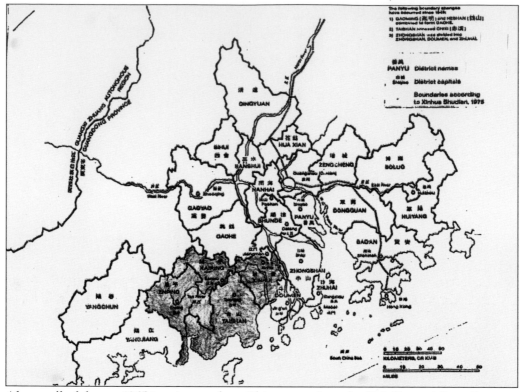

Almost all of the pre-1965 immigrants from China came from the Siyi (Szeyup) Four Counties part of Guangdong province. The Four Counties (shaded) are located about 50 miles from Guangzhou, the provincial capital of Guangdong province. (Courtesy Chinese American Museum of Northern California.)

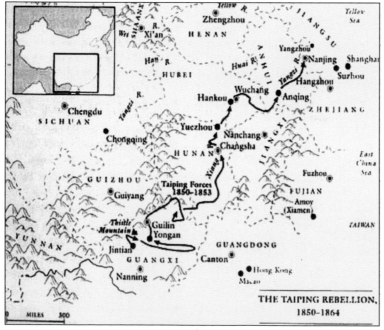

Led by a Cantonese, the Taiping Rebellion started in Guangxi province (located northwest of Guangdong province) and headed in a northeasterly direction to engage the Qing Dynasty forces located to the north. (Courtesy Chinese American Museum of Northern California.)

THE TAIPING REBELLION, 1850–1864

Two

THE EARLY MARYSVILLE CHINATOWN

The Chinese who settled in Marysville during the Gold Rush were almost all Siyi people. For the most part, they were farmers, experienced in growing rice, fruit, and vegetables. Their skills and technology in moving earth and water would prove useful in mining gold. Almost as soon as they arrived in Marysville, they set in roots, building a temple and organizing tongs and other associations.

Marysville was the supply point for the gold areas in the mountains to the east. Riverboats would steam their way upriver to Sacramento (Yeefow, Second Port) then to Marysville (Sanfow, Third Port) and unload their cargo of mining equipment, supplies, and food. From Marysville, they loaded up mule trains to take the cargo to the miners. By 1882, the Marysville Chinatown had 42 businesses, most of them "general merchandise" stores. The number of Chinese businesses in Marysville would remain almost constant during the next 70 years, with 40 businesses in 1952.

Over the years, the Suey Sing Tong, the Hop Sing Tong, and the Marysville Chinese Community proved to be the most important associations in town. In addition to these associations, the Hip Yee Tong, the Chee Kong Tong, the Chinese Reform Party, and the Kuomingtang also maintained offices in Marysville. The Chinese community opened a Chinese school to educate their children. In the early years, the Chinese school was quite important as Chinese children were not allowed to enroll in the Marysville public schools. It was not until sometime around the end of the 19th century that the first Chinese child was admitted into a Marysville public school.

Gambling halls were also part of the business scene in Marysville. Local officials were paid to look the other way so the gambling halls could operate. More than half of the patrons were non-Chinese, with keno being a particularly popular game with European American ladies. The winning numbers were posted in the lobby of a hotel near Chinatown, where the ladies would gather, drink wine and tea, and wait to see if they had hit a winning combination of numbers.

Marysville in the beginning of 1850s was a Gold Rush boomtown. By 1855, it had a population nearing 10,000. The town had mills, ironworks, machine shops, factories, as well as schools, churches, and two daily newspapers. The center of Chinatown was at First and C Streets on the map. (Courtesy Yuba County Library.)

This view looking south on D Street shows the D Street Bridge that leads into the center of downtown Marysville. This picture was taken in the 1920s. (Courtesy Gordon Tom.)

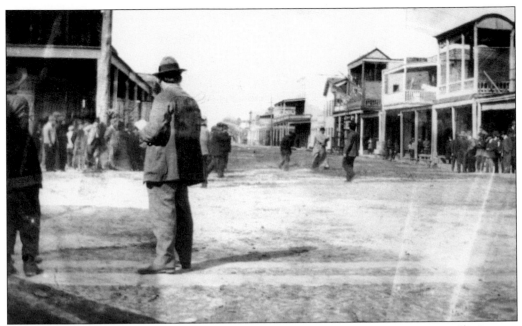

This is a picture of the center of Marysville Chinatown at the intersection of First and C Streets. It was taken in the 1890s looking north on C Street. (Courtesy Gordon Tom.)

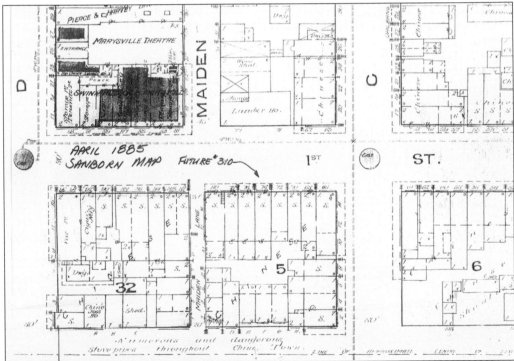

The 1885 Sanborn Map of Marysville's Chinatown showed the Chinese occupying most of the buildings except for the ones at the top left of the picture. The old addresses were two digits, which were later converted to three digits. For example, 74 First Street became the present 310 First Street. (Courtesy Yuba County Library.)

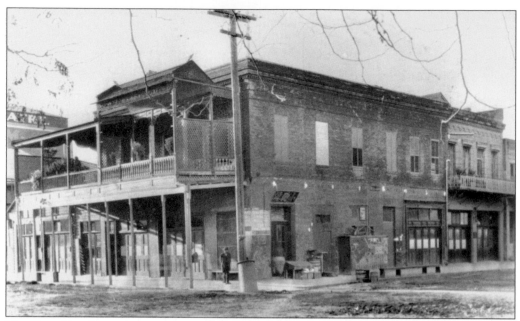

The Suey Sing Tong Association was established in Marysville in the early 1870s at 305 First Street. Similar to the other tongs formed in America at that time, the organization supported its members by settling grievances and helping its members find employment. In July 1936, a fire destroyed the building. It was quickly rebuilt and rededicated in 1937. (Courtesy Chinese American Museum of Northern California.)

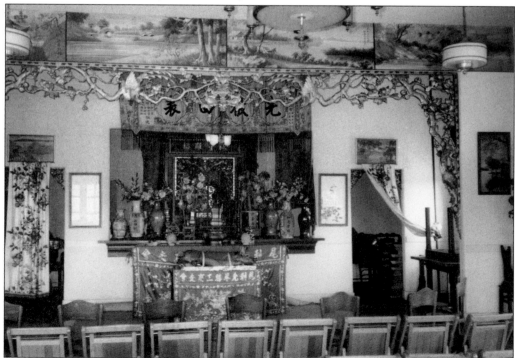

This is the main room in the Suey Sing Tong at 305 First Street. The altar is located in this room for worship. (Courtesy Chinese American Museum of Northern California.)

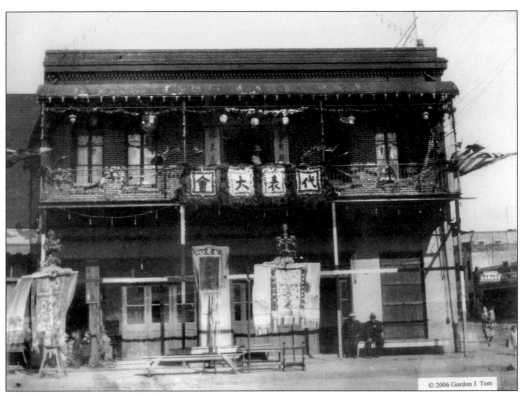

Suey Sing Tong Association has always played an important role in the celebration of the Bok Kai Festival. This picture was taken in the 1920s. (Courtesy Gordon Tom.)

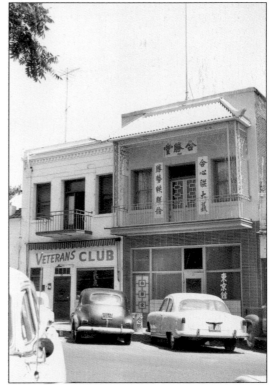

Hop Sing Tong Association was established in Marysville in 1873. It is one of the three remaining Chinese organizations in Marysville. The association moved into the current building at 113 C Street in 1918. The association remodeled and expanded its lodge hall to include two additional buildings in 1952. (Courtesy Bing Ong.)

The last location of the Chinese School in Marysville was at 226 First Street. The structure was built in 1888 and was the Chin Hang Lum Herb Company prior to the Chinese School. The Chinese community purchased the building and dedicated it as a Chinese School. The building was used as a school from 1945 to the 1970s. (Courtesy Marysville Library.)

The Kim Wing Building, constructed in 1860 at 228 First Street, was the business and home of Joe (Chow) Kim Wing and his family. Joe Kim Wing was a very successful merchant of Chinese goods, so much so that he was able to add a second floor to the building in the 1920s. (Courtesy Yuba County Library.)

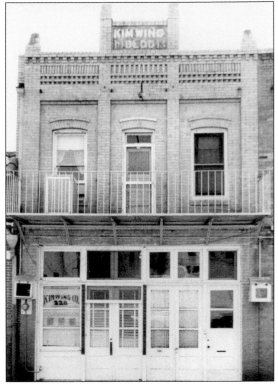

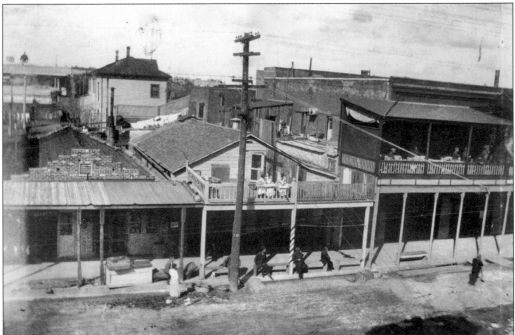

This picture was taken across First Street looking at 303–311 in Marysville Chinatown. Suey Sing Tong is to the right of the picture. The picture was taken around 1900. (Courtesy Gordon Tom.)

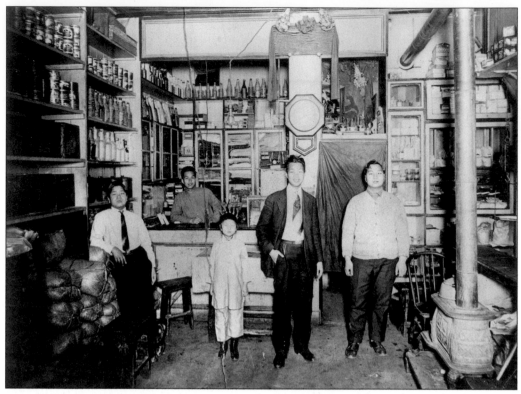

This is the inside of the Tung Wo store at 310 First Street in 1918. The business was established by Hom Kun Foo. From left to right are Hom S. Hing (Arthur Tom Sr.), Hom K. Gim (Eva Tom), Hom S. Suey, and Hom S. Lung. Behind the counter is Hom S. Kay. (Courtesy Chinese American Museum of Northern California.)

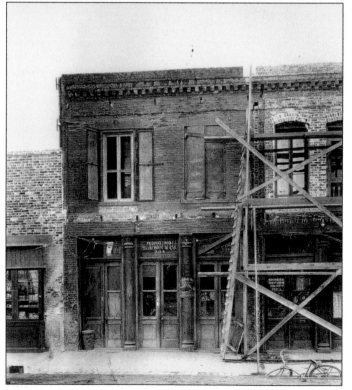

The building at 304 First Street was occupied by the Hong Wo Sun Kee and Company, a business started in the 1870s. The structure at 306 First Street housed the Chinese Reform Party and later the Quong Hong On Company. (Courtesy Yuba County Library.)

The building at 309 First Street was the residence of the Leong family. The Ying Bun Company occupied 307 First Street during the 1940s. Many of the businesses that sold only Chinese products gradually closed as a result of the decline in Chinese population. (Courtesy Gordon Tom.)

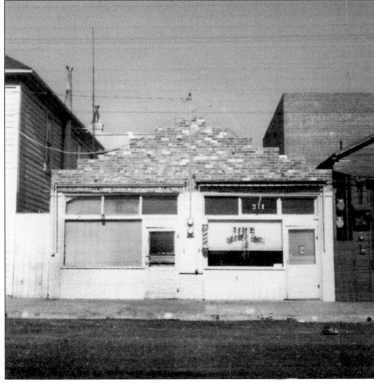

The store at 311 First Street was the Sun Wo barbershop during the 1930s and 1940s. It was later purchased by Tim Lim when he arrived from China in 1948. The store on the left at 313 was the Fong On and Company. (Courtesy Gordon Tom.)

This building is located at 312 First Street. It was the home of the Gar Yee family. The brick building was constructed in 1853. It was remodeled in the 1980s and is still standing today. (Courtesy Yuba County Library.)

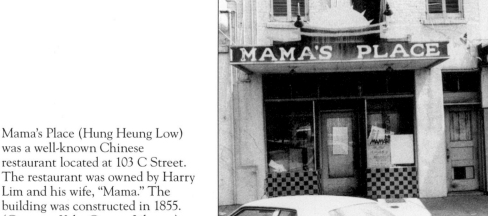

Mama's Place (Hung Heung Low) was a well-known Chinese restaurant located at 103 C Street. The restaurant was owned by Harry Lim and his wife, "Mama." The building was constructed in 1855. (Courtesy Yuba County Library.)

This building is located at 110 C Street. It was home of the Ong Tall family. Ong Tall operated the Kings Inn restaurant across the street at 101 C Street. In 1947, he opened Lotus Inn, the upscale Chinese restaurant on Second and Oak Streets. (Courtesy Yuba County Library.)

The U.S. Hotel was located at the southwest corner of Third and C Streets on the northern edge of the Marysville Chinatown. The street level became the Marysville Furniture Store started by Arthur M. Tom Sr. in 1949. The building was later demolished for the new Yuba County Library in 1971. (Courtesy Bing Ong.)

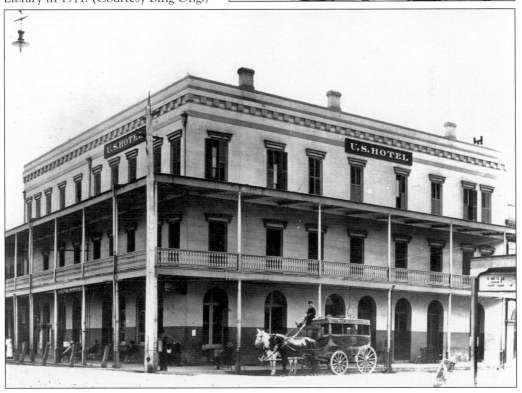

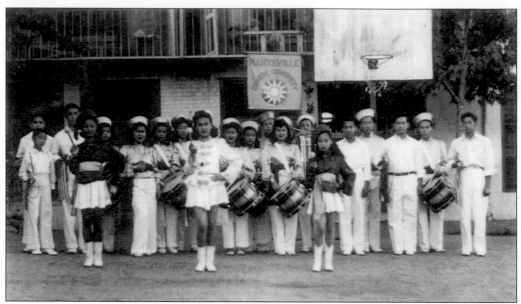

The Marysville Chinese Community, Inc., or Chung Wah, sponsored the drum and bugle corps in the 1940s. The majorettes, from left to right, were Virginia Ong, Clara Waugh, and Ruthie Waugh. In the back row, from left to right, were Frank Kim, in the back, Leland Tom, Bill Suey, Connie Tom, Katie Foo, Ella Kim, Beulah Foo Wong, Doreen Foo, Mary Ong, Gene Sing Lim, Jeannie Kim, Jimmy Lim, David Wing, Ben Tom, Charlie Lim, John Wing Lee, and Robert Yee. (Courtesy Gordon Tom.)

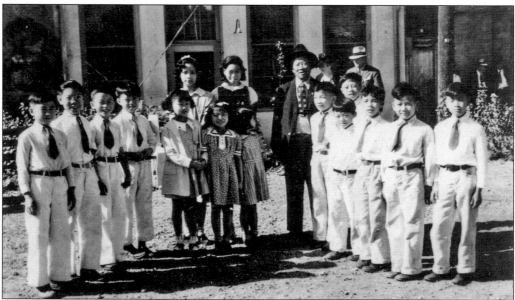

These Chinese students are posed in the playground area of Chinatown in 1940. The boys on the left are, from left to right, Johnny Yee, Leland Tom, Henry Kim, and Gene Sing Lim. The girls are, from left to right, (first row) Doreen Foo, May Tom, and Irene Tom; (second row) Alice Hom and Lily Tom. The boys on the right are, from left to right, Ben Tom, Gene Wong Lim, Gene Sing Lim (in the back), Stanley Hom, Charlie Lim, and Bobby Leong. The teacher is Mr. Yong. (Courtesy Virginia Ong Gee.)

Photo By Hom Shoo Suey

Photo / G.J.Tom Collection

These students pose in front of the Chinese School located on 16 C Street in 1940. The Chinese School operated at this location for 10 years from 1935 to 1945 before relocating to 226 First Street. (Courtesy Gordon Tom.)

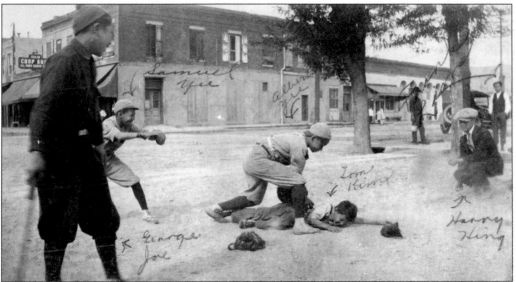

This was a common scene in the Chinatown playground at First and C Streets in the 1920s. The following people are pictured here, from left to right: George Joe, Samuel Yee, Albert Yee, Tom Kim, unidentified, Harry Hing, and Frank Lim. (Courtesy Brenda Wong.)

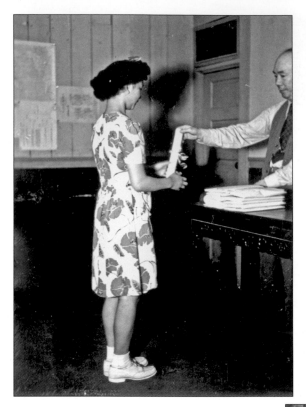

The Chinese School was a very important part of the Chinese community. Ella Kim is shown receiving her diploma at the Chinese School at 16 C Street in the early 1940s. (Courtesy Gene Sing Lim.)

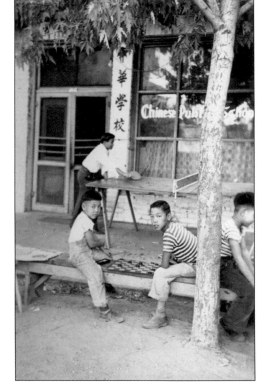

This picture showed James Yee (left) and Frank Kim (right) playing checkers during recess in front of the Chinese School at 16 C Street in 1940. James became a pharmacist, and Frank became a judge. (Courtesy Gene Sing Lim.)

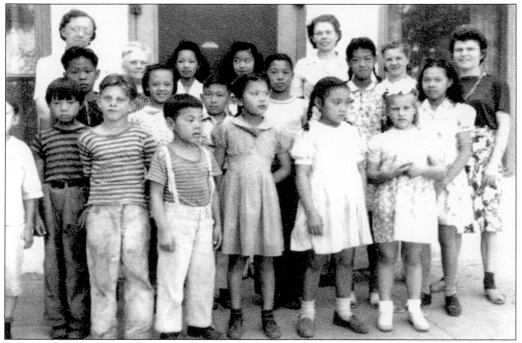

When not attending public or Chinese School, the Chinese children would participate in the activities of the Presbyterian Mission Church. The Mission Church operated at 24 C Street between the late 1920s and the 1960s. Some of the children in this early-1940s picture are James Yee, Emily Chin, Helen Yee, Mona Yee, Carrie Lim, Frank Kim, Virginia Ong, Mary Ong, and Marie Yee. (Courtesy Gene Sing Lim.)

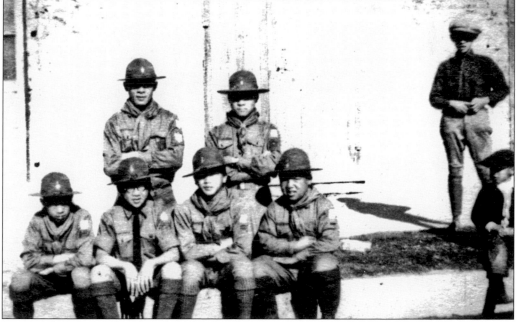

In 1924, the Chinese Presbyterian Mission Church sponsored the Boy Scouts of America Chinese Troop No. 5. (Courtesy Brenda Wong.)

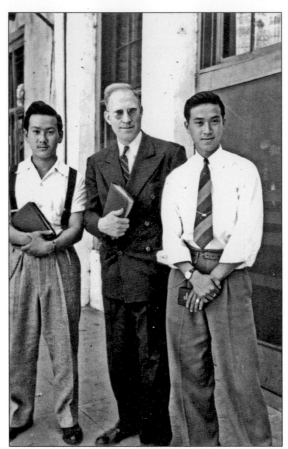

The two older students of the Chinese Presbyterian Mission Church, Charlie Lim (left) and Bill Suey (right), are standing next to the teacher, Mr. Prelesch, in the early 1940s. (Courtesy Gene Sing Lim.)

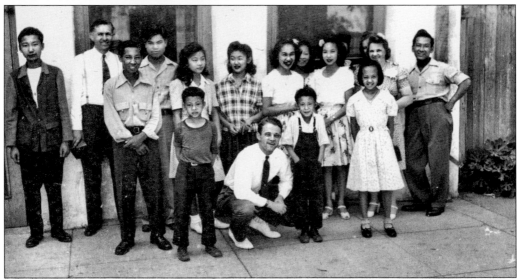

This picture was taken of older children attending the Chinese Presbyterian Mission Church. Some of the children in the picture are David Wing, Robert Lim, Paul Lim, Carrie Lim, Charlie Lim, Mary Ong, Clara Waugh, and Virginia Ong. The picture was taken in 1942. (Courtesy Gene Sing Lim.)

Three

THE BOK KAI TEMPLE AND FESTIVAL

The importance of the Bok Kai Temple in the history of the Chinatown in Marysville cannot be overemphasized. This is the one institution that has held the Chinese people together for the past 150 years. It continues to play that role today, as the Bok Kai Festival is one of the largest community celebrations in town.

The Bok Kai Temple in Marysville is unlike other Chinese temples in larger Chinatowns. Most Chinese temples in California were built by a single association or organization and thus open only to members. In Marysville, the Chinese long ago agreed to band together and build one temple that would be used by all. As a result, many worshippers, including many new immigrants to America, have come to Marysville to worship at the temple.

An important part of the temple's activities is the Bok Kai Festival, or Bomb Day, sponsored by the Bok Kai Temple and the Marysville Chinese Community every year on the second day of the second month of the lunar New Year. In former years, other Chinatowns also celebrated this holiday. Today it is only celebrated in Marysville.

Traditionally during the Bok Kai Festival, Chinatown opened it doors to everyone, with large free banquets and busy gambling halls. Today many older Chinese Americans remember the Bomb Day celebration of the 1950s and 1960s when the Chinese of Marysville were so hospitable.

The Bok Kai Festival would not be complete without the firing of the bombs on Sunday afternoon. The "bombs" are large firecrackers with a round bamboo ring on top. Around the ring is a red banner on which is written a good fortune. If one were so lucky as to catch one of the rings, he would take it to the temple, register the banner, and make a donation to the temple. Today the tradition continues, and if anything, the festival has gotten more popular, with larger crowds gathering annually for what may be the last traditional Chinese celebration in America.

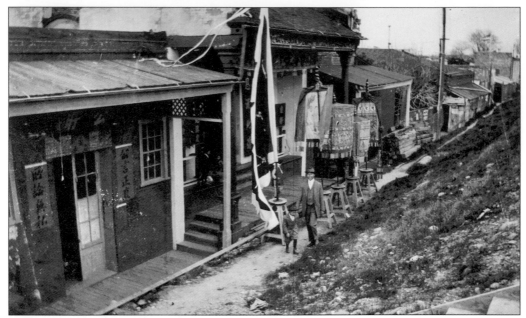

The Bok Kai Temple (The Temple of the North Shore) was opened in 1854 as a place of worship for Chinese to pay tribute to Bok Eye, the North God, and four other Chinese gods. The Bok Kai Temple was relocated to its present location in 1880 and is the only Chinese temple that has been continuously used for worship since that time. This is one of the earliest pictures of the temple, taken in the late 1800s. (Courtesy Gordon Tom.)

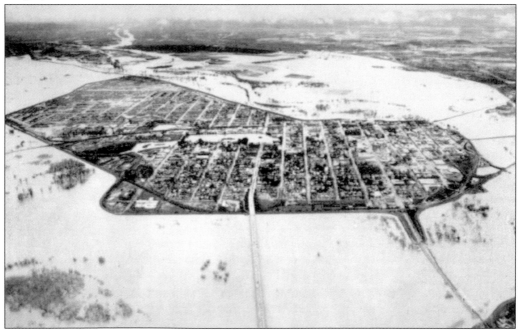

This is a December 1955 picture of the high water surrounding Marysville. The water, after several days of heavy raining, started flowing over the top of the levee next to the Bok Kai Temple. However, at the very last moment, a break occurred farther downriver, relieving pressure to the levees that protected the town. (Courtesy Yuba County Library.)

Joe Lung Kim was a native of Marysville Chinatown. He operated the Kim Wing store at 228 First Street. He was a leader in the Chinese community and the curator/caretaker of the Bok Kai Temple from 1960 to 1985. (Courtesy Yuba County Library.)

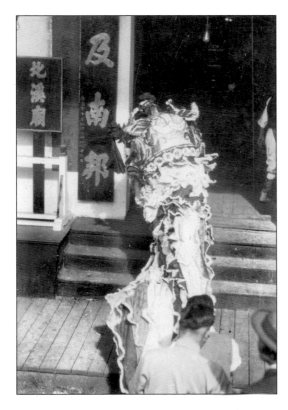

This picture taken in the early 1950s during Bomb Day shows a lion performing a dance at the entrance to the Bok Kai Temple. (Courtesy Brenda Wong.)

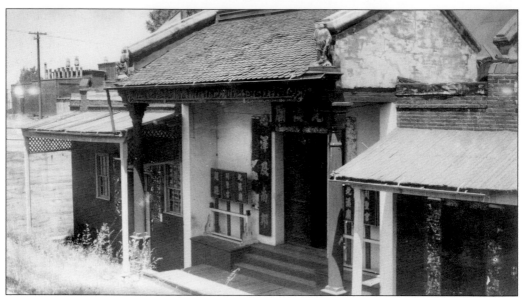

This picture of the Bok Kai Temple was taken in the 1930s. (Courtesy Bing Ong.)

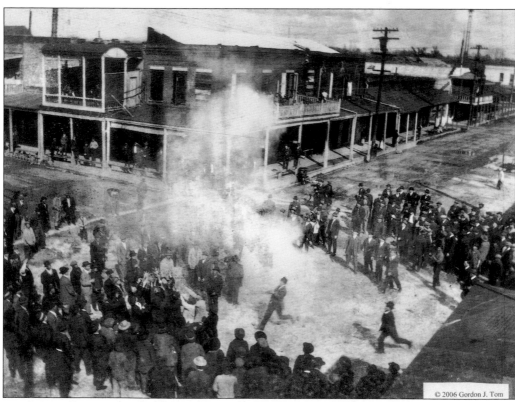

© 2006 Gordon J. Tom

Bomb Day takes its name from the firing of the bombs, which is a tribute to the North God, Bok Eye. This annual event began in the middle of the 19th century. This picture taken around 1900 is the earliest known picture of the firing of the bombs. (Courtesy Gordon Tom.)

Jimmy Pon was the third bomb maker for the Bok Kai Festival from 1981 to 1993. The bombs, resembling giant firecrackers, are handmade in Marysville specifically for Bomb Day. A special permit and license are issued each year by the state fire marshal to the Marysville Chinese Community for this annual production of approximately 100 bombs. Only 10 to 15 bombs are now fired during the festival. (Courtesy Chinese American Museum of Northern California.)

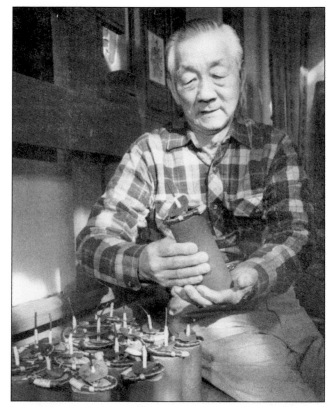

The firing of the bombs attracts a lot of spectators. The excitement reaches a high point after the firing as the bamboo ring descends downward. This picture was taken in the early 1950s. (Courtesy Virginia Ong.)

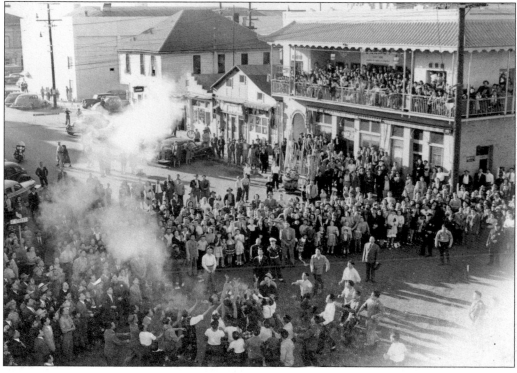

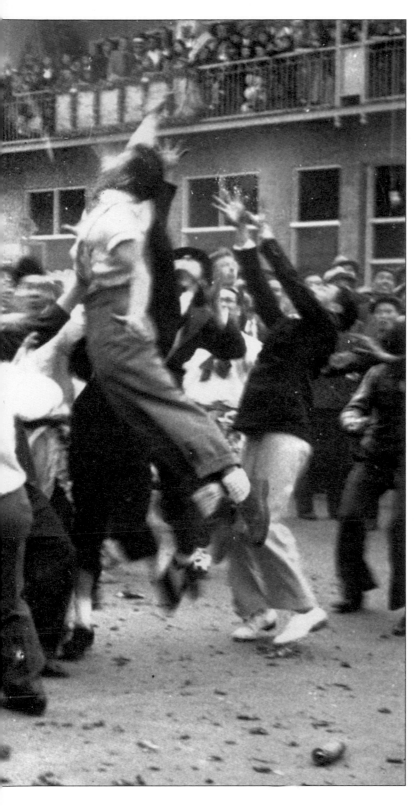

The firing of the bombs takes place at the intersection of First and C Streets. They are fired in a roped arena where young Chinese, and occasionally adults, scramble for the "good fortune" rings that are shot into the air along with the bombs. Marysville is the only place in the United States that still celebrates Bomb Day. The picture was taken in 1947. (Courtesy Jack Kim.)

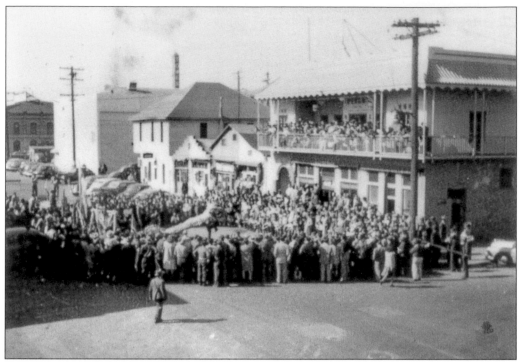

Bomb Day is not complete without the traditional Lion Dance. The dance always draws a large crowd of people to witness the event. The lion is performing in front of the Suey Sing Tong Building on First Street in the late 1940s. (Courtesy Gene Sing Lim.)

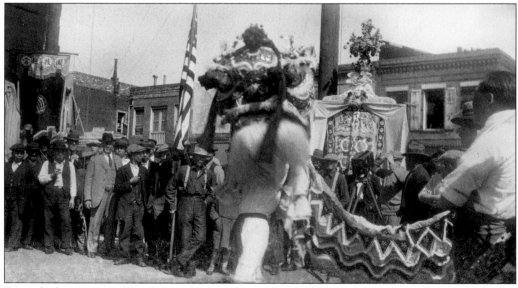

From the beginning of Bomb Day, the Lion Dance has been an important part of the celebration. Here at the center of Chinatown, the lion is doing a dance with a motion picture camera rolling. The picture was taken in February 1926. (Courtesy Brenda Wong.)

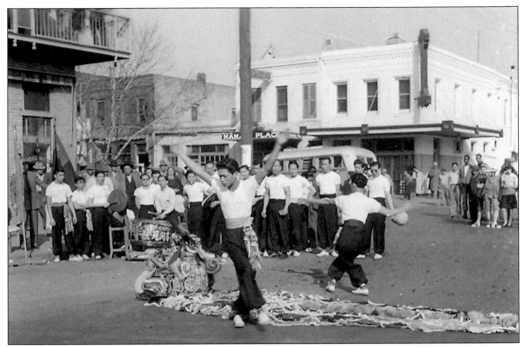

Two kung fu martial artists are preparing themselves for the Lion Dance. The dance is based on traditional kung fu footwork, kicks, and stances so both participants must have a solid background in kung fu. This photograph was taken in the 1940s. (Courtesy Jack Kim.)

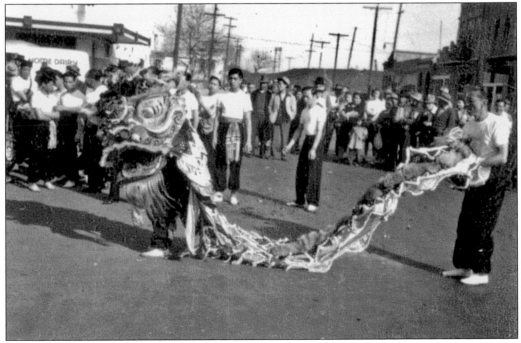

The Chinese Lion Dance goes back some 1,000 years. Businesses would hang green leafy vegetables with paper currency attached over their doorway or balcony for an offering to the lion. this photograph was taken in the 1940s. (Courtesy Gene Sing Lim.)

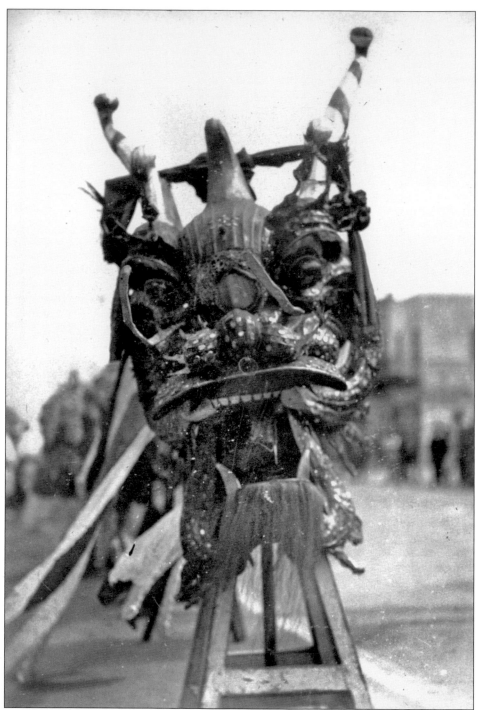

The first dragon, Gum Lung, was crafted by artisans in China and shipped to Marysville in the 1890s at a cost over $5,000. Gum Lung was so well known that Chinese communities in New York, Chicago, Los Angeles, San Francisco, Seattle, and other cities borrow him for their parades. It paraded last in Marysville in 1930s. Gum Lung has been subsequently replaced by two other dragons. (Courtesy Brenda Wong.)

This is an early picture of the Gum Lung dragon taken before 1900. The Chee Kung Tong building is in the background with the canopy. (Courtesy Gordon Tom.)

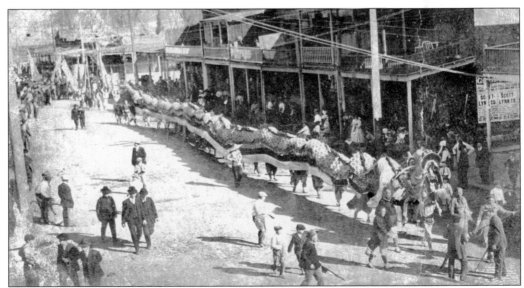

Gum Lung has started its journey through Chinatown on First Street. (Courtesy Yuba County Library.)

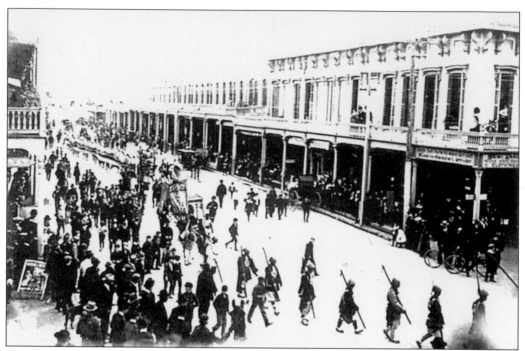

The parade was not only a Chinese event to honor the North God, Bok Kai, in Chinatown, but the whole Marysville community also participated. This picture is the 1891 parade. (Courtesy Chinese American Museum of Northern California.)

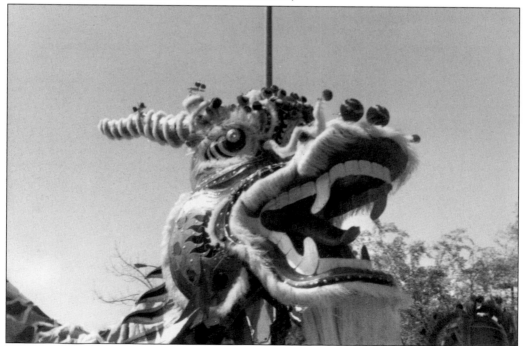

The current Gum Lung is more colorful than earlier ones in past years. Its appearance is still, however, both frightening and bold, but it has a benevolent disposition. (Courtesy Yuba County Library.)

Bing Ong, a community leader in Chinatown, for many years began the Bomb Day parade with a striking of the gongs on the parade route. (Courtesy Bing Ong.)

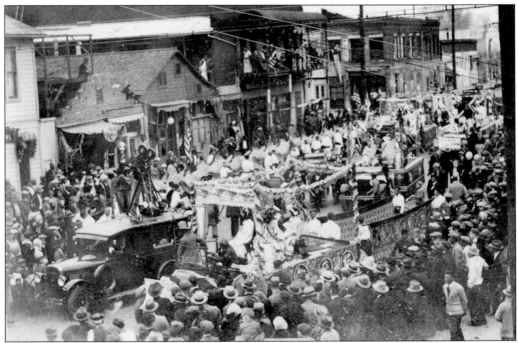

This picture is the Bomb Day parade through Chinatown on First Street between Oak and C Streets in 1931. Universal Newsreel Company covered this event and released one minute of film clips to show in movie theaters across the country. (Courtesy Brenda Wong.)

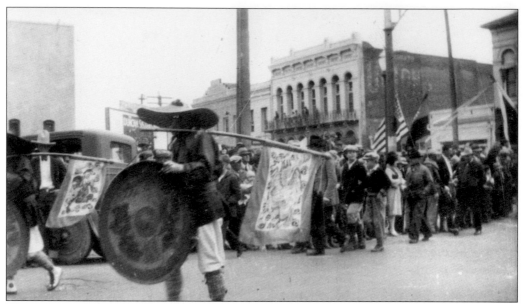

The 1938 Bomb Day parade included gongs that were sounded along the route. A pole is used to balance the heavy gong. (Courtesy Yuba County Library.)

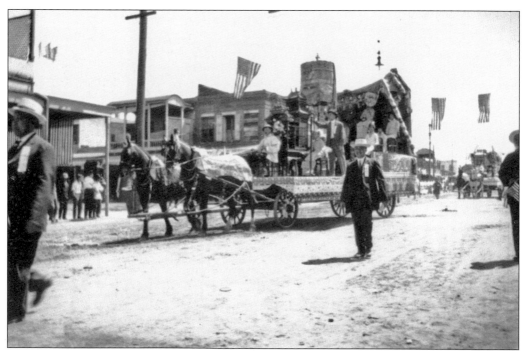

A parade float is at the intersection of First and C Streets in front of the Suey Sing Tong building. This picture was taken in the 1890s. (Courtesy Gordon Tom.)

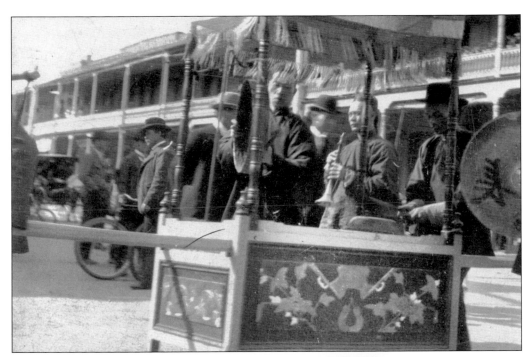

The musicians are taking a rest on the parade route on D Street. The carrier, similar to a sedan chair, is used to hold the drum for the drummer. The long poles are used by two bearers to carry the drum while it is being played. This picture was taken in the 1890s. (Courtesy Chinese American Museum of Northern California.)

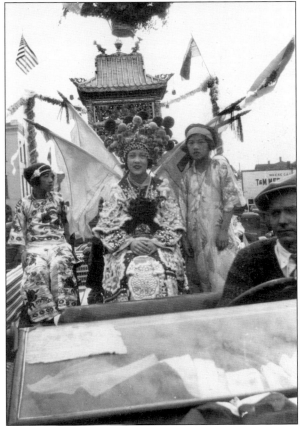

The 1931 Bomb Day celebration was a very elaborate affair. There were many Chinese floats in the parade. This is a picture of Aimee Fong in the center of the float on D Street. (Courtesy Brenda Wong.)

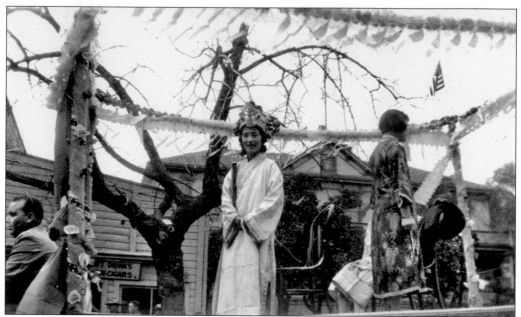

Anna Mae Juke was the center of attention on this float during the Bomb Day parade in 1931. (Courtesy Brenda Wong.)

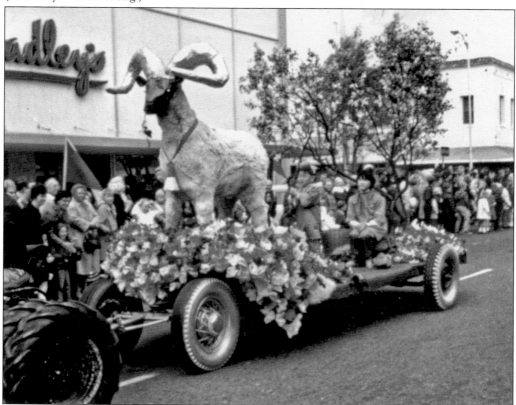

The Twin Cities Chinese Club sponsored a float for many years in the Bomb Day parade. This is the float for the 1967 parade, the year of the ram. (Courtesy Gordon Tom.)

Tim Lim was chosen as the grand marshal of the Bomb Day parade in 2000. Tim was an active leader of the Chinese community for decades and the owner of the Tim's Barber Shop at 311 First Street. (Courtesy Gordon Tom.)

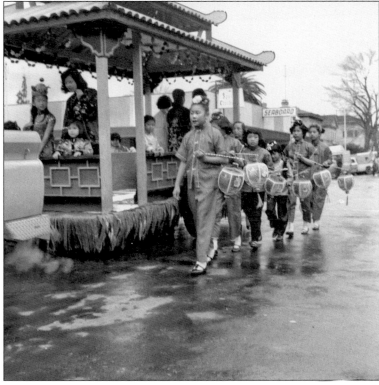

The children of the Chinese families in the local community also participated in the Bomb Day parade. This picture was taken in the 1960s. (Courtesy Gordon Tom.)

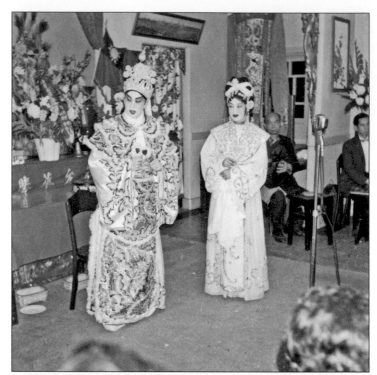

Other entertainment during the Bomb Day celebration included opera singers from San Francisco performing at Suey Sing Tong. This picture was taken in 1947. (Courtesy Gordon Tom.)

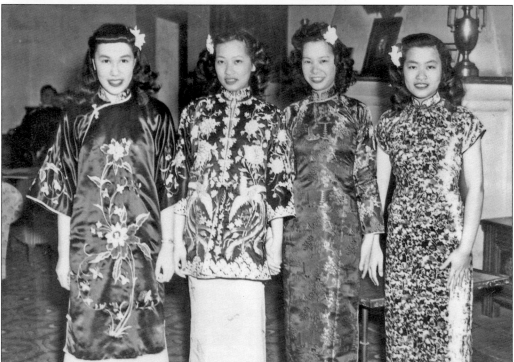

Four of the contestants competing for the queen of Bomb Day are dressed in traditional Chinese dress at the 1947 Bomb Day Dance. They are, from left to right: Clara Waugh, Virginia Ong, Ella Kim, and Mary Ong. (Courtesy Virginia Ong Gee.)

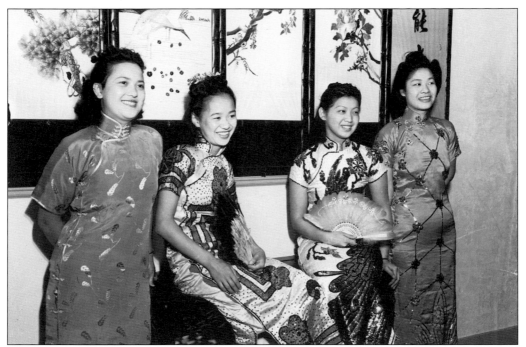

Young Chinese girls would dress up in their traditional Chinese dresses during the Bomb Day celebration. In this 1938 picture are, from left to right, Pearl Lim, Bertha Waugh, Helen Jang, and Helen Yee. (Courtesy Yuba County Library.)

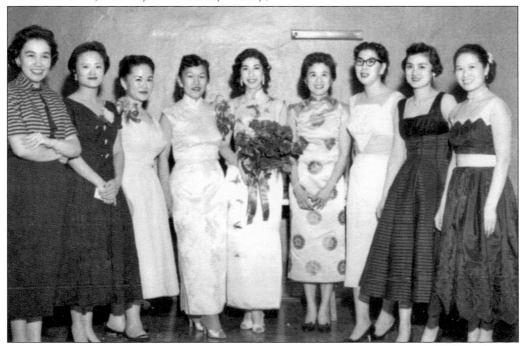

The Twin Cities Chinese Club held the 1957 Bomb Day dance at the Friendship Hall. Ruby Kwong (center) was the guest of honor at the dance. She was presented with a bouquet of flowers. In the picture are Clara Waugh (left) and Katie Foo (fourth from left). (Courtesy Gordon Tom.)

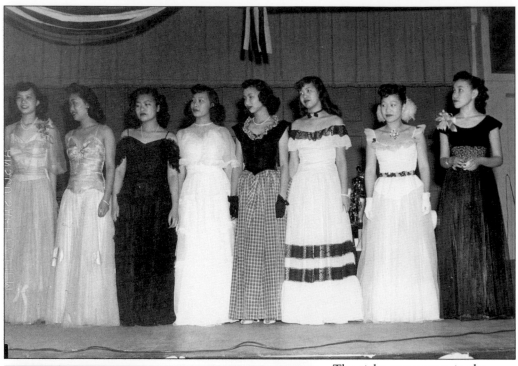

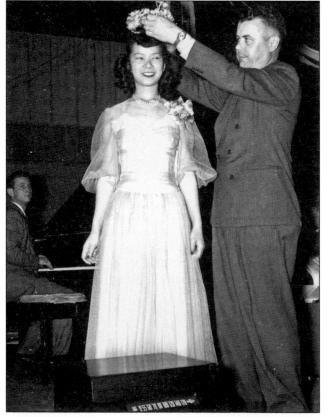

The eight contestants in the running for the Queen of Bomb Day in 1947 are anxiously awaiting the final decision for the selection of the queen. From left to right, the eight contestants are Ella Kim, Doreen Foo, Mary Ong, Virginia Ong, Ruth Waugh, May Tom, unidentified, and Clara Waugh. (Courtesy Virginia Ong Gee.)

The highlight of the 1947 Bomb Day Dance was the crowning of the queen. Ella Kim, an 18-year-old Marysville Union High school student, was crowned as the queen of Bomb Day by Harold Sperbeck, a Marysville city councilman and mayor. (Courtesy Virginia Ong Gee.)

Four

THE EARLY CHINESE PIONEERS OF MARYSVILLE

When news of the Gold Rush in California reached Asia, it hardly caused a ripple. In Asia, only the people of Guangdong province understood what the Gold Rush meant. For years, the Cantonese had been waiting for just such an opportunity: wealth beyond imagining, free for the taking, in a land without mandarin officials. The combination of riches and freedom was too great. Within weeks of hearing about the discovery, the Cantonese were headed for California, many to towns like Marysville.

The early Chinese pioneers came from a society that was almost the polar opposite of America. "Strangers in a strange land" was how they described themselves. The myth has been created that China sent its lowest and poorest to America. The reality was that China sent its best and brightest. Starting from the beginning, it was the strongest and most alert in the village that decided to join the Gold Rush.

Most came from the Siyi area of Guangdong from more established families who had the savings necessary for the journey. Landing in San Francisco, they secured supplies and headed out for the gold country. Many traveled to the southern mines where the mountains were not so rugged and winters milder. Others boarded river boats for the northern mines, through Yeefow (Sacramento, Second Port) on their way to Sanfow (Marysville, Third Port).

The Chinese loved this new land. They often commented about how the hot, humid summers resembled the weather back in the old country. For the first two decades, the Chinese concentrated on mining. Then later they opened laundries, restaurants, theaters, and gambling halls. In 1870, the Chinese constituted over half of the California miners. They were by far the largest group of railroad workers who built the Central Pacific portion of the transcontinental railroad. In 1880, the percentage of California's labor force in various occupations that were Chinese was as follows: agriculture 14 percent, vegetable gardens 48 percent, launderers 80 percent, boot makers 52 percent, cigar makers 85 percent, woolen mill operators 33 percent, and fishermen 39 percent. In every significant industry, the Chinese were an important factor who helped build California into a great state.

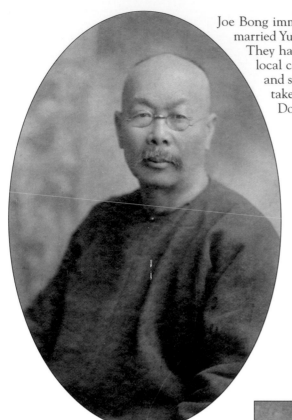

Joe Bong immigrated to the United States in 1867. He married Yuet Woon Lew in the latter part of the 1870s. They had six children. He was a farmer in several local communities. He later moved to Marysville and started a laundry business. This picture was taken in 1890. (Courtesy Brenda Lee Wong and Doreen Foo Croft.)

Yuet Woon Lew (Mrs. Joe Bong) was born in China in 1860. She came to America in 1871 at the age of 11 and later married Joe Bong. (Courtesy Brenda Lee Wong and Doreen Foo Croft.)

Hom Kun Foo joined the California Gold Rush in 1851. He mined in the northern mines, making Marysville his home base. After striking it rich, he opened a general store at 310 First Street. The store would remain in business for over 100 years. He married Lee Shee from a well-known Fresno family, and they had nine children. (Courtesy Chinese American Museum of Northern California.)

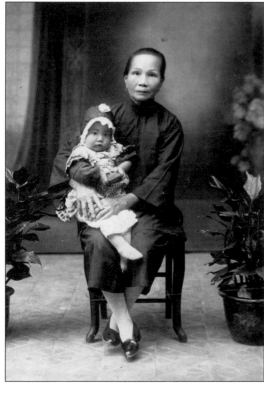

Lee Shee was from a prominent family in Fresno. She married Hom Kun Foo in 1885. In this picture she is holding her granddaughter Elsa Hom, daughter of Hom Lin and Yee Shee. (Courtesy Gordon Tom.)

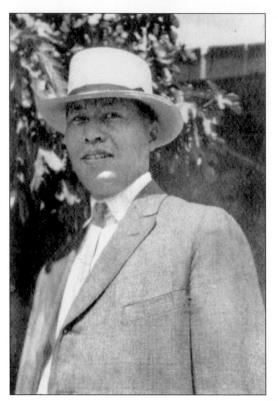

Joe Waugh was born in 1886 in Yuba City. He was a houseboy for Hiram Johnson, a prominent lawyer who later became a state senator. Joe Waugh and his brother, Joe Foo Sr., were the first Chinese students to attend public school in the local community. He had an excellent command of both the English and Chinese languages. This ability qualified him to be a translator for the county, state, and federal courts. He married Daisy Hing and had five children. (Courtesy Brenda Lee Wong and Doreen Foo Croft.)

Joe Foo Sr. was born in 1888. He was a leader in the Suey Sing Tong Association. He married Nellie Hong and, after her death, Leta Foley. He had four children. (Courtesy Brenda Lee Wong and Doreen Foo Croft.)

Arthur M. Tom Sr. was born in 1904 in Marysville. He attended Marysville public school until he was 16 and then traveled to China to be trained as a Chinese herb doctor. He was a well-known business leader in Marysville. Among his many business ventures, Tom was a partner with his brothers in Union Market, owned the Golden Eagle gas station and the Marysville Furniture store, and established a corporation that had three Savemor department stores. This picture was taken in 1933 in the front reception room of his herbal office at 602 D Street. (Courtesy Chinese American Museum of Northern California.)

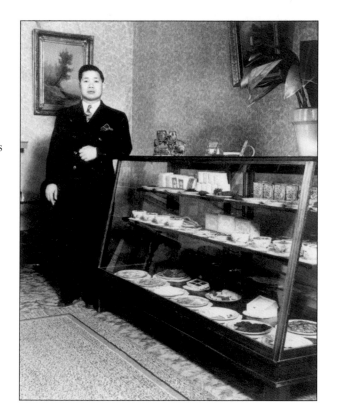

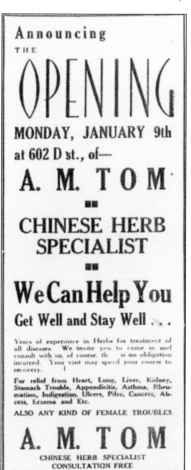

Announcing

THE

OPENING

MONDAY, JANUARY 9th

at 602 D st., of—

A. M. TOM

CHINESE HERB SPECIALIST

We Can Help You

Get Well and Stay Well . . .

Years of experinece in Herbs for treatment of all diseases. We invite you to come in and consult with us, of course, th is no obligation incurred. Your visit may speed your course to recovery.

For relief from Heart, Lung, Liver, Kidney, Stomach Trouble, Appendicitis, Asthma, Rheumatism, Indigestion, Ulcers, Piles, Cancers, Abcess, Eczema and Etc.

ALSO ANY KIND OF FEMALE TROUBLES

A. M. TOM

CHINESE HERB SPECIALIST
CONSULTATION FREE

602 D Street Marysville Phone 757

Arthur M. Tom Sr. had the grand opening of his herbal practice in 1933 with an advertisement in the local newspaper, the *Appeal Democrat*. (Courtesy Chinese American Museum of Northern California.)

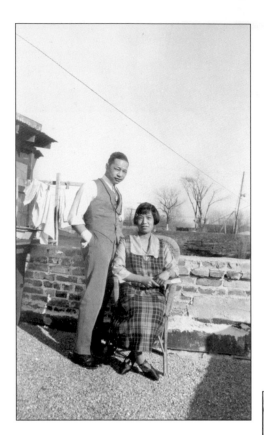

Lung Pon Kim Wing was born in Marysville in the 1890s. He and his wife, Helen Tom, managed the Kim Wing Company at 228 First Street that his father had established. (Courtesy Frank Kim.)

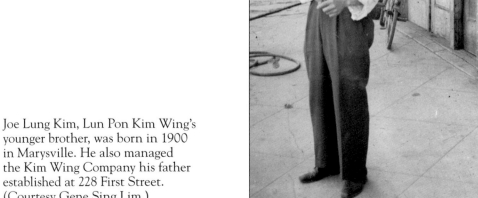

Joe Lung Kim, Lun Pon Kim Wing's younger brother, was born in 1900 in Marysville. He also managed the Kim Wing Company his father established at 228 First Street. (Courtesy Gene Sing Lim.)

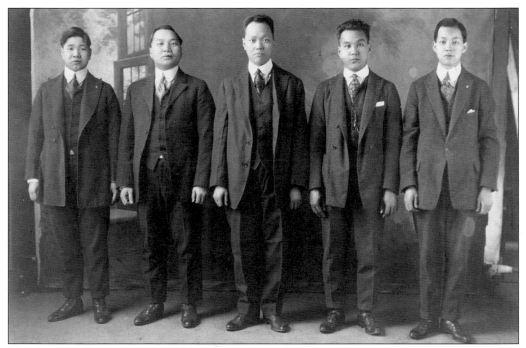

These are the five sons of Hom Kun Foo, who owned the Tung Wo store at 310 First Street. They are, from left to right: Hom S. Hing (Arthur M. Tom Sr.), Hom S. Lung, Hom S. Lin, Hom S. Kay, and Hom S. Suey in 1928. (Courtesy Chinese American Museum of Northern California.)

These are the 1910 partnership papers of Tung Wo at 310 First Street. Each partner had $1,000 interest in the business. Hom Kun Foo was the manager of the business. (Courtesy Chinese American Museum of Northern California.)

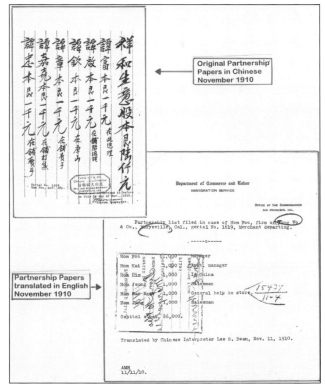

Samuel Yee was born in Marysville in 1909. He attended University of California Hastings College of Law at the age of 38. He later became a judge in San Francisco. (Courtesy Brenda Lee Wong.)

Jennie Jue, the first daughter of Joe Bong, was born in 1884. She married Ten Song Dong from a well-to-do family from Watsonville. They had nine children; four of them became physicians and one a dentist. The picture was taken in 1900. (Courtesy Brenda Lee Wong and Doreen Foo Croft.)

Hom S. Lung, third son of Hom Kun Foo, was born in Marysville in 1897. He married Lee Gim Ong in China in the 1920s. He was a businessman in Marysville and San Francisco. He and his fourth brother, Hom S. Suey, purchased a large building at 1019 Stockton Street in Chinatown and named it for their father, Hom Kun Foo. The sign at the top of the building displays the Chinese characters for "Hom Kun Foo." (Courtesy Gordon Tom.)

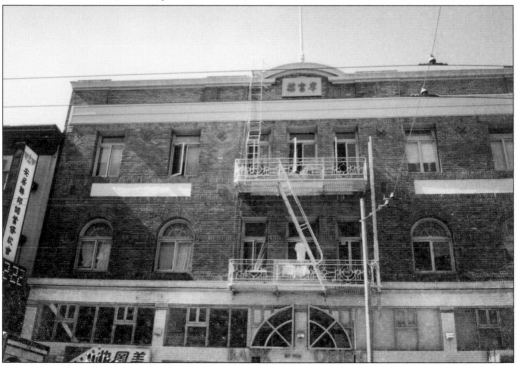

Ong Tall operated Kings Inn at 101 C Street in the 1930s and 1940s. In 1947, he opened Lotus Inn, the Chinese restaurant at 315 Second Street. (Courtesy Virginia Ong Gee.)

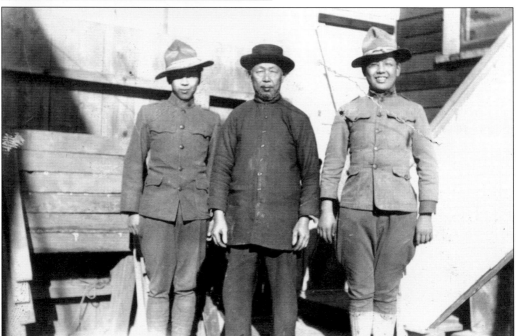

Joe Bong was very proud of his two sons, Joe Foo (left) and Joe Waugh (right), who enlisted in the army during World War I. After they returned from the war, they joined the local branch of the American Legion. (Courtesy Brenda Lee Wong.)

Five

SURROUNDING CHINATOWNS

The Chinatown in Marysville was always considered the social, political, and commercial center for all the nearby Chinatowns. The largest nearby Chinatown was in Oroville, almost the size of the one in Marysville at one time. Today it is known for being the home of one of the most magnificent old Chinese temples in America. The Oroville Chinese Temple is a complex of three separate temples, the main Liet Sheng Kong Temple, or Temple of Many Deities, a Buddhist Moon Temple, and the Chan Family Confucian Temple. The temple is now operated as a city park and museum and is no longer open to the public for worship.

The Chico Chinatown was actually three small Chinatowns. Much of the early development of Butte County, where Chico and Oroville are located, can be traced to the early work of the Chinese in mining, lumber, and agriculture. Then, beginning in the 1870s, with the hard work completed, European workers joined the movement to expel the Chinese. Perhaps to signal their extreme position, a local group, the Supreme Order of the Caucasians, was formed to drive the Chinese out of Butte County.

This group threatened to "annihilate" any white person who did not join, following a tactic used many times before of intimidating the pro-Chinese forces into submission. Half of the Oroville Chinatown was burned down in 1876. During 1876 and 1877, terrorists, always in the dead of night, set many fires in the Butte County Chinatowns. On March 14, 1877, the terrorists attacked again. On a ranch several miles outside Chico, six Chinese workers were sleeping in their cabin when armed terrorists burst into their cabin. Lining up the Chinese men, they fired. Four of the Chinese died.

The Chinese responded by arming themselves. In time, along with the impact of the Chinese Exclusion Act, the Chinese population in Butte County declined. Many moved to Marysville, a town that had a more established Chinatown. Today in Chico, the only evidence that the Chinese once played a large role in the building of the town is an altar from one of the old Chinese temples displayed in the local city museum.

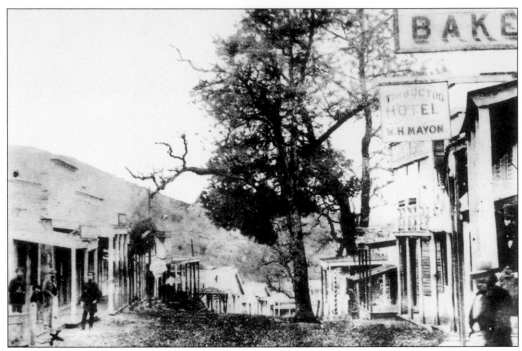

In 1850, the first miners started to pan along the Yuba River at what is known as Timbuctoo. By 1855, Timbuctoo was the largest town in eastern Yuba County. During the 1870s, the town had four Chinese-owned stores and a laundry. (Courtesy Yuba County Library.)

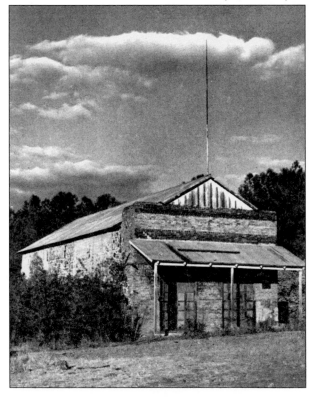

This picture shows the last structure in Timbuctoo before it was demolished. It was built in the 1850s. The building was originally a Wells Fargo office before it became the Suey Sing Store. (Courtesy Yuba County Library.)

Gee Quong Leong came to America in 1883 and established the Jee Wah Tong store on Broderick Street in the Oroville Chinatown. He was a leader in the Chinese community. He married Hom K. Hen from Marysville in 1910 and had two children, Edward and Herbert. He is shown with his son Edward in 1911. (Courtesy Chinese American Museum of Northern California.)

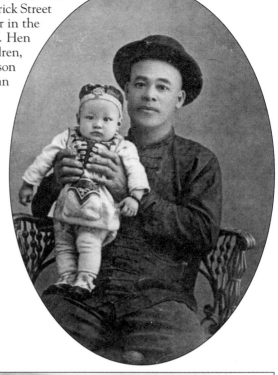

The Jee Wah Tong building was located on 1698 Broderick Street in Oroville and operated by Gee Quong Leong. This picture was taken in 1947. (Courtesy Chinese American Museum of Northern California.)

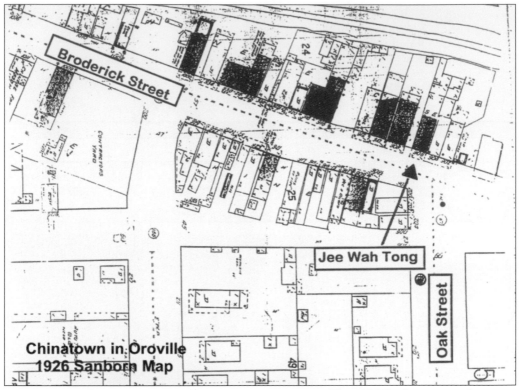

Broderick Street

Jee Wah Tong

Oak Street

Chinatown in Oroville
1926 Sanborn Map

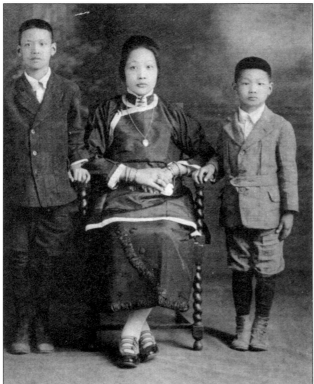

The 1926 Sanborn map of Oroville Chinatown shows Jee Wah Tong, located on 906 Broderick Street. The address was subsequently changed to 1698. (Courtesy Yuba County Library.)

Hom K. Hen was born in 1890 in Marysville. She married Gee Quong Leong in 1910 and had two sons, Edward and Herbert Gee. After the passing of her husband, she continued managing Jee Wah Tong until the mid-1930s. Edward and Herbert graduated as engineers from the University of California, Berkeley. This picture was taken in the 1920s. (Courtesy Chinese American Museum of Northern California.)

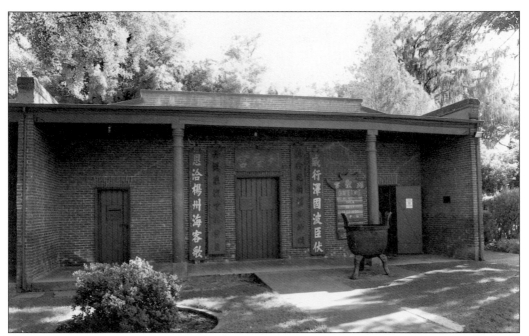

The Chinese Temple in Oroville was built in 1863 to serve the increasing number of Chinese residents. At the time, it consisted of a temple for the Taoists worshippers, a storehouse, and a theater. The Moon Temple was constructed in 1868 for the Buddhists, and the Chan Room was added in 1874 for Confucians. (Courtesy Chinese American Museum of Northern California.)

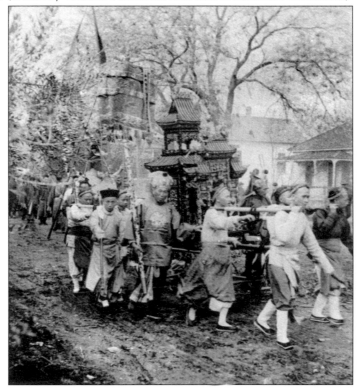

In 1860, it was estimated that 15 percent of the population in Butte County was Chinese. With such a large Chinese population, celebration of the Lunar New Years with parades was a very common event. This parade occurred in Oroville in 1880. The faces of the participants show they were intensely proud of their culture. (Courtesy Oroville Chinese Temple.)

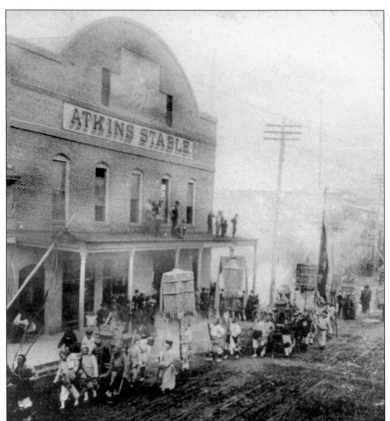

The Chinese New Year's parades not only marched through Chinatown but through the main business street of Oroville. Many of the local residences came out to view the parade in 1880. (Courtesy Oroville Chinese Temple.)

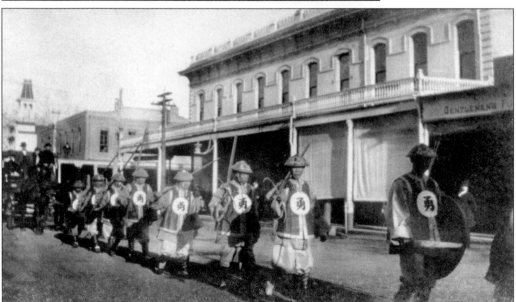

This is a Chinese funeral procession on Second Street in Chico in 1880. The Graves building is in the background. The Chinese are wearing the finest silk and satin clothing. The Chinese character on the vest means "brave" or "courageous." (Courtesy California State University, Chico, Meriam Library, Special Collections.)

These are two of the remaining five Chinese buildings in the Oroville's Chinatown. The building on the left was an herb store, and the store on the right was a laundry. (Courtesy Chinese American Museum of Northern California.)

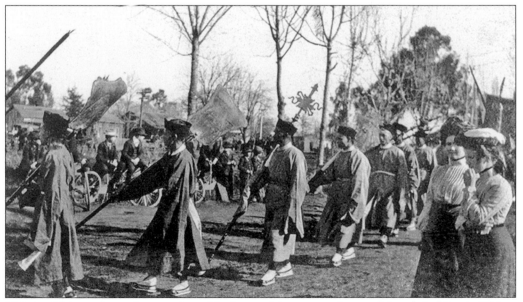

This is a Chinese funeral procession with the participants wearing traditional clothing in Chico. The picture was taken before 1900. (Courtesy California State University, Chico, Meriam Library, Special Collections.)

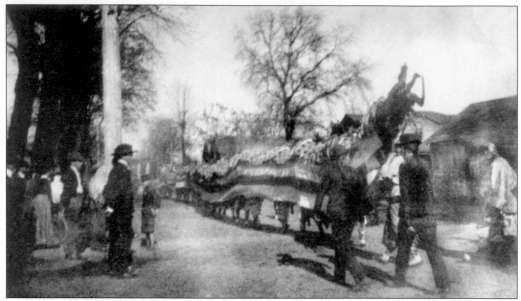

The parading of a block-long dragon is a common sight in Chinese celebration. This dragon was used in Chico prior to the dawn of the 20th century. (Courtesy California State University, Chico, Meriam Library, Special Collections.)

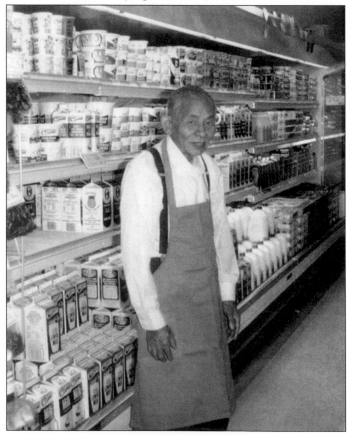

Kam Kee Lee was considered the godfather of Chinese American supermarkets in the Central Valley. He opened his first grocery store in Colusa in 1921, called Chung Sun Grocery. (Courtesy Gordon Tom.)

Six

THE ANTI-CHINESE MOVEMENT AND THE CHINESE AMERICAN RESPONSE

Terrorism is violence, the threat of violence, or other harmful acts committed for political or ideological goals. The 19th-century terrorists of the anti-Chinese movement used both violence and the threat of violence to achieve their political goal of excluding and expelling the Chinese from the United States. Their targets were Chinese Americans and the European Americans who supported them. Throughout this dark period of American history, many Chinese Americans fought back, both in the courts and in the streets, by arming themselves.

In the Chinatowns of the 1870s and 1880s, carrying pistols became very common. An event recorded in the *Alta California* of April 12, 1885, illustrates the point. Two officers, a policeman and a sheriff's constable, went to the Marysville Chinatown to execute an arrest warrant on a Chinese woman. In those days, many of these warrants were not legitimate but were often used to intimidate the Chinese. When the officers arrested the Chinese woman and were about to take her to jail, a Chinese man "with a large revolver" pulled it out and aimed it directly at the constable. Six other Chinese men with revolvers joined him and chased the constable and policeman back to the station house, firing over 20 rounds in the process. The article concluded by noting that the prisoner escaped.

Fighting the anti-Chinese movement, the Chinese took their battle to the American justice system. In 1892, the United States passed the Geary Act, which required every Chinese person in America to register and carry an identity card to prove that he was legally in America. The identity card was similar to a system that had developed during America's slave era when a freed slave had to carry papers to prove that he was free or face arrest. The Chinese refused to obey this law. Only after losing their case in the U.S. Supreme Court did the Chinese finally register. Some historians have characterized the loss of the Supreme Court case a defeat for Chinese Americans. But in truth, it was a defeat for all Americans.

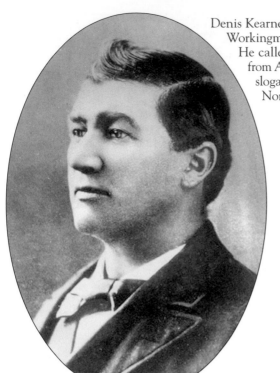

Denis Kearney, an Irish immigrant, was the leader of the Workingmen's Party in California during the late 1870s. He called for the expulsion of Chinese immigrants from America. "The Chinese must go" was Kearney's slogan. (Courtesy Chinese American Museum of Northern California.)

The slogan of "the Chinese must go" is shown in this illustration from the late 19th century. Two European American supporters of the Chinese were murdered to send a message to those who supported equality for Chinese Americans. (Courtesy Chinese American Museum of Northern California.)

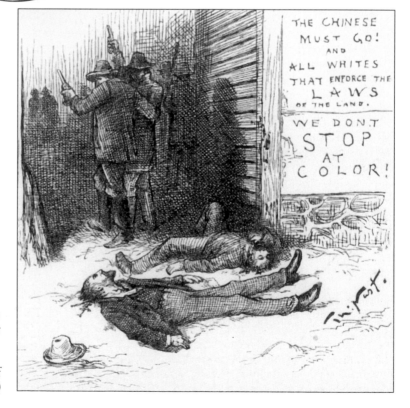

THE CHINESE MUST GO! AND ALL WHITES THAT ENFORCE THE LAWS OF THE LAND. WE DON'T STOP AT COLOR!

In the early 1880s, the San Francisco Police Department established its so-called Chinatown Squad to control and harass Chinese Americans. No Chinese American felt safe from the brutal tactics of these policemen. The squad was disbanded in August 1955 upon the request of the influential *Chinese World* newspaper, which had editorialized that the squad was an "affront to Americans of Chinese descent." (Courtesy San Francisco Police Department.)

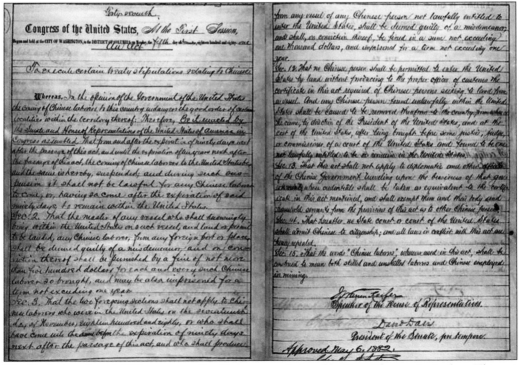

The Exclusion Act of 1882 was passed by Congress and signed by Pres. Chester A. Arthur. This act provided that Chinese laborers were excluded from immigration to America. (Courtesy Chinese American Museum of Northern California.)

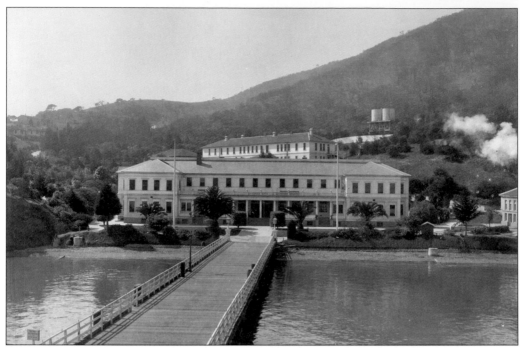

The first stop for the Chinese immigrants was the administration building on Angel Island upon disembarking at the pier. All Chinese immigrants had to be processed here during the years it was active. (Courtesy National Archives Pacific Region San Francisco.)

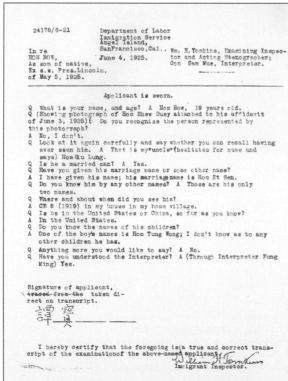

```
24178/6-21        Department of Labor
                  Immigration Service
                  Angel Island,
In re             SanFrancisco,Cal., Wm. H.Tomkins, Examining Inspec-
HOM BOW,              June 4, 1925.     tor and Acting Stenographer;
As son of native,                     Con  Sam Mue, Interpreter.
Ex s.s. Pres.Lincoln,                 ----------
of May 5, 1925.

                  Applicant is sworn.

Q  What is your name, and age?  A  Hom Bow,  19 years old.
Q  (Showing photograph of Hom Shew Suey attached to his affidavit
   of June 3, 1925)[:  Do you recognize the person represented by
   this photograph?
A  No, I don't.
Q  Look at it again carefully and say whether you can recall having
   ever seen him.  A  That is my "uncle" (hesitates for name and
   says) Hom Siu Lung.
Q  Is he a married man?  A  Yes.
Q  Have you given his marriage name or some other name?
A  I have given his name; his marriage name is Hom Et Sen.
Q  Do you know him by any other names?  A  Those are his only
   two names.
Q  Where and about when did you see him?
A  CR 8 (1919) in my house in my home village.
Q  Is he in the United States or China, so far as you know?
A  In the United States.
Q  Do you know the names of his children?
A  One of the boy's names is Hom Tung Wong; I don't know as to any
   other children he has.
Q  Anything more you would like to say?  A  No.
Q  Have you understood the Interpreter?  A  (Through Interpreter Fung
   Ming)  Yes.

Signature of applicant,
traced from the  taken di-
rect on transcript.

    I hereby certify that the foregoing is a true and correct trans-
cript of the examination of the above-named applicant
                                          William H. Tomkins
                                          Immigrant Inspector.
```

The Immigration and Naturalization Service (INS) at Angel Island would question the incoming Chinese at length to determine if he or she was eligible for admission into the United States. This is the one of several entry interviews of Hom Bow in 1925. One of his other interviews required a 25-page transcript. He was denied entry. (Courtesy National Archives Pacific Region San Francisco.)

Thomas J. Geary, a Democratic congressman from California, introduced the bill in 1892 that became law and was known as the Geary Act. It required all Chinese residents of the United States to carry a resident permit, a sort of internal passport. Failure to carry the permit at all times was punishable by deportation or one year of hard labor. (Courtesy Chinese American Museum of Northern California.)

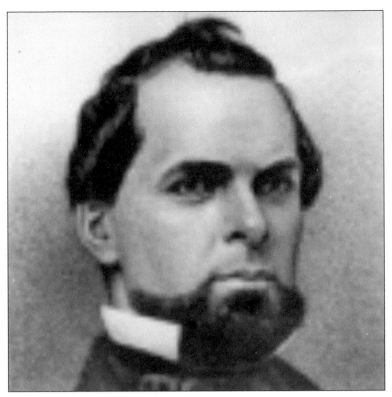

Joe Foo Sr. was born in 1888. This photograph was from a document in 1894 that stated "United States of America Certificate of Residence" issued to Chinese laborer under the provisions of the act of May 5, 1892. Though he was a United States citizen, he was still required to carry this document. (Courtesy Brenda Lee Wong and Doreen Foo Croft.)

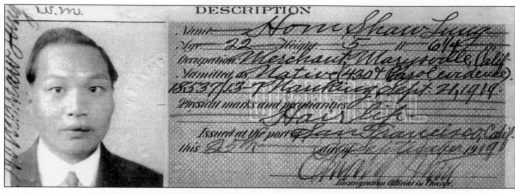

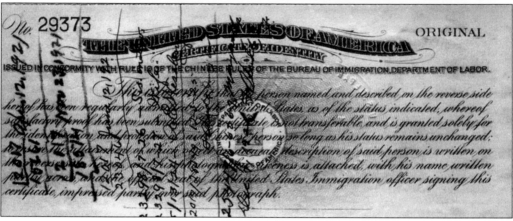

Hom S. Lung was born in 1897 at 310 First Street in Marysville. Though he was a United States citizen, he still was required to have a certificate of identification issued by the Bureau of Immigration, Department of Labor. (Courtesy Gordon Tom.)

In order for a Chinese person to leave America and return, he was required to apply for a return certificate. One of the ways to acquire a return certificate was to prove he was a partner in a business. This document, dated July 31, 1912, is the first page of the finding by the inspector on his interview with Lim Chung of the Kim Wing store on First Street. It was an adverse recommendation. (Courtesy National Archives Pacific Region San Francisco.)

Seven

THE CHINESE PIONEER FAMILIES OF MARYSVILLE

Starting a Chinese American family in America proved to be extremely difficult. During the Gold Rush, it was mainly men who came to California because of the primitive and frontier conditions of the state. As the Chinese pioneers built their Chinatowns and prepared for the coming of their wives, racist laws would impede their progress. In 1875, the Page Act was passed, which treated every Chinese woman entering the United States as a potential prostitute. The fanaticism by which this law was enforced discouraged many Chinese women from being reunited with their husbands for more than a generation.

The next step the racists took to hinder the formation of Chinese American families was to deprive Chinese men of a way to make a living. Local and state laws were passed to limit occupations in which the Chinese could work. Chinese boot makers, cigar makers, and woolen mill operators were driven out of their jobs by union campaigns and the union label. Chinese in agriculture were forced out of the small-town Chinatowns by a campaign of terror led by the Order of Caucasians. Soon the only work left was in laundries, restaurants, herb shops, and gambling halls.

The most onerous law was the Chinese Exclusion Act. Passed in 1882, it made it almost impossible for Chinese American men to return to China to marry or visit their families. If they left America, there was no assurance they could return to their home here in America. If they married, the chances they could bring their wives and children to America were slim. The Chinese Exclusion Act was inhumane and made more so by its implementation by cruel officials. Trying to raise a family when their children were excluded from public schools, limited in their vocations, restricted in housing choices, and forced at every turn to defend their rights in court, it is a wonder any Chinese American families survived at all.

The numbers tell the story. In 1870, Chinese Americans were nine percent of the California population, by 1950, less than one percent.

The Hom Kun Foo and Lee Shee family lived at 310 First Street. They had nine children, all born at that address. The family picture was taken in 1906. The youngest daughter was added

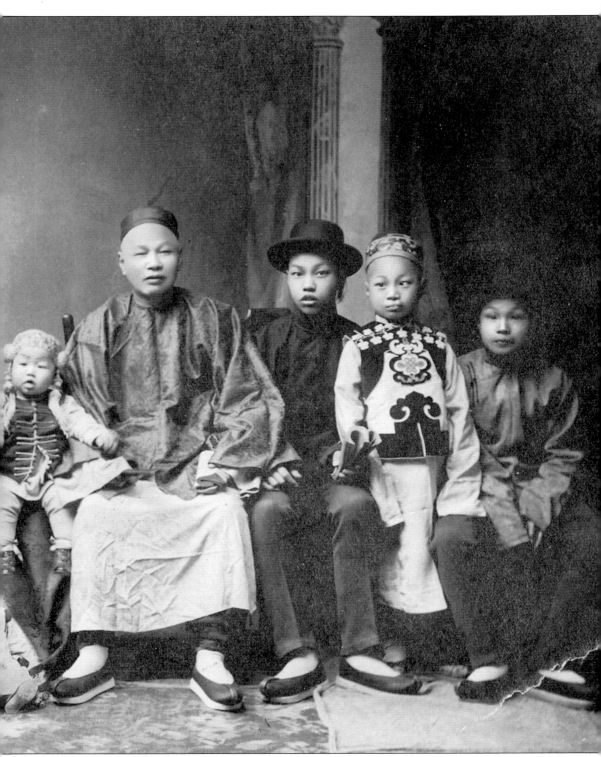

onto the picture in 1909. Hom Kun Foo was a successful merchant and owned and operated the Tung Wo store. (Courtesy Chinese American Museum of Northern California.)

The Lim Foo family lived at 232 First Street. The family operated a bean sprout plant at that location in the back room. They not only supplied bean sprouts to all the Chinese restaurants in the Marysville/Yuba City area, but they also shipped them by rail to other communities, such as Chico, Colusa, Oroville, and as far north as Dunsmuir, 180 miles away. In the 1956 picture, from left to right, are Jack Lim, Paul Lim, Mrs. Lim Tong Foo, Barbara Lim, Joy Lim, Carrie Lim, and Mabel Lim. (Courtesy Gene Sing Lim.)

Jennie Jue, born in 1884, was the oldest daughter of Joe Bong and Yet Woon Lew. She married Ten Song Dong and had nine children. Five of the children entered the medical profession. Emma Dong, MD, was the first female to be accepted into University of California, San Francisco, ophthalmology department. Collin Dong, the second son, was one of the first Chinese Americans to graduate from Stanford Medical School. (Courtesy Brenda Lee Wong and Doreen Foo Croft.)

The center of the Marysville Chinatown was the playground at First and C Streets. The location made it an ideal place to hold events for the Chinese community. This picture was taken in the late 1930s on the playground with the community leaders and some of their children. (Courtesy Chinese American Museum of Northern California.)

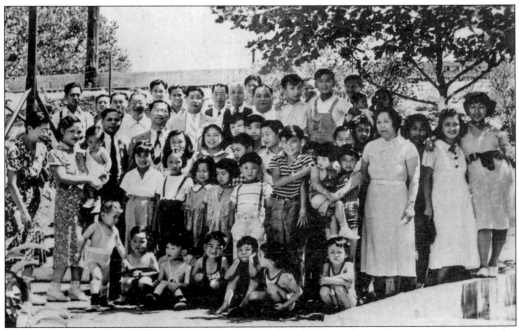

This picture was taken at First and C Streets in the playground area. Shown are some of the Chinatown residents in 1936. (Courtesy Virginia Ong Gee.)

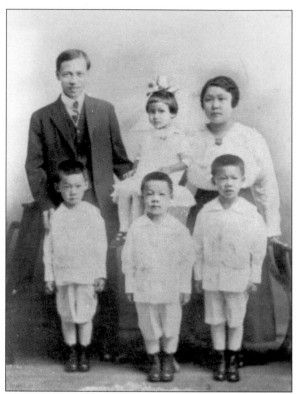

Bessie Jue was born in 1887. She married Tien Yee and had four children. One of their children, Samuel, became a judge in San Francisco. (Courtesy Brenda Lee Wong and Doreen Foo Croft.)

This formal picture was taken during the Lunar New Year in 1918. From left to right are (seated) Violet Yee and Alice Dong; (standing) unidentified, brothers Albert Yee, Ernest Yee, and Samuel Yee, and Gar Yee, a friend. (Courtesy Brenda Lee Wong and Doreen Foo Croft.)

This is a group of Chinese girls from Marysville Chinatown in 1921. Violet Yee is the girl with the big bow in her hair. (Courtesy Jack Kim.)

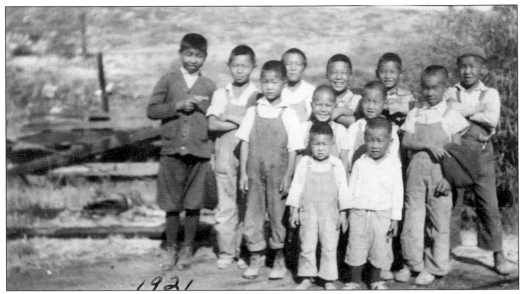

This picture is some of the Chinese boys from Marysville Chinatown in 1921. Included are Samuel Yee, Albert Yee, and Ernest Yee. (Courtesy Jack Kim.)

This picture was taken in February 1926 of James Tom, Albert Yee, Herbert Fong, and Albert Tom in the playground area of First and C Streets. Albert Yee is wearing a block M on his sweater, which was awarded to outstanding athletes in sports at Marysville High School. (Courtesy Brenda Lee Wong.)

The playground in Chinatown was a popular area for socializing by the Chinese teenagers. In the 1943 picture, sitting on the bench from left to right, are Ken Ang, Johnny Yee, Jack Lee, Bobby Leong, and Frank Kim. In the back, standing, are unidentified, unidentified, Hong Kong Charlie, Jack Kim, Gene Sing Lim, David Wing, unidentified, Ella Kim, and Jack Tom. (Courtesy Gene Sing Lim.)

Joe Lung Kim of the Kim Wing
Company at 228 First Street
is shown with his wife, Ida.
(Courtesy of Gene Sing Lim.)

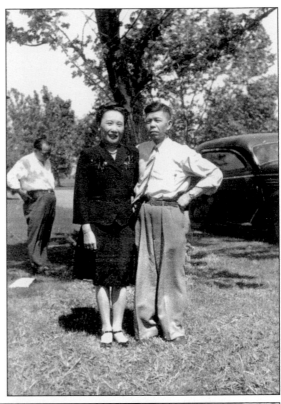

Bing Ong immigrated to America in
1937 at the age of 14. He managed the
Lotus Inn, a restaurant in Chinatown
that his father started. He is a longtime
elder and a well-known community
leader in Marysville. Bing is shown
with his wife, Ellen, and father, Ong
Tall. This picture was taken in the
late 1940s. (Courtesy Bing Ong.)

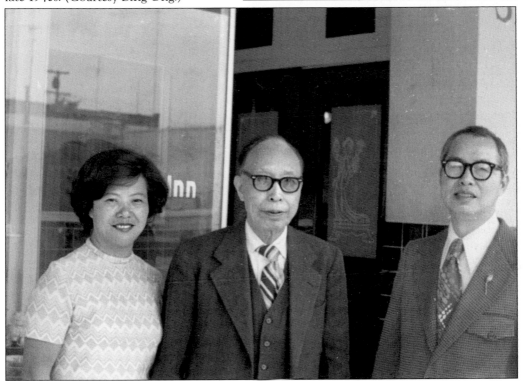

Anne Jue was the youngest daughter of Joe Bong and Yuet Woon Lew. She was born in 1889 and married Gong Mar in 1910. She appeared in the movie *Toll of the Sea* starring Anne Mae Wong. This is a picture taken in the 1920s. (Courtesy Brenda Lee Wong and Doreen Foo Croft.)

Bertha Waugh was born in Marysville in 1924. She had a love for tap dancing. One of her teachers was Danny Daniels, who taught many actors and actresses how to tap dance. Some of her classmates were Nannette Fabray, Hal Linden, Marge Champion, and Dick Van Dyke. She worked in a plumbing business as a bookkeeper and later became the first licensed female plumbing contractor in the state of California. She married George Chan, who was an art director of movies and television. In 1970, George was nominated for an Academy Award for best art director for the production of *Gaily, Gaily*. This picture was taken in 1940. (Courtesy Brenda Wong.)

These were children from families in Chinatown. In the picture are Katie Foo, Doreen Foo, Virginia Ong, Mary Ong, and Carrie Lim. (Courtesy Virginia Ong Gee.)

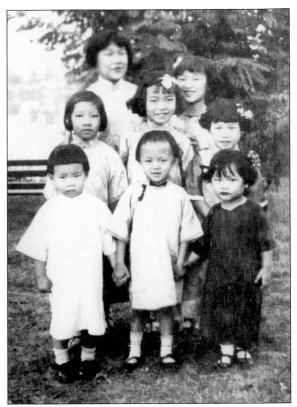

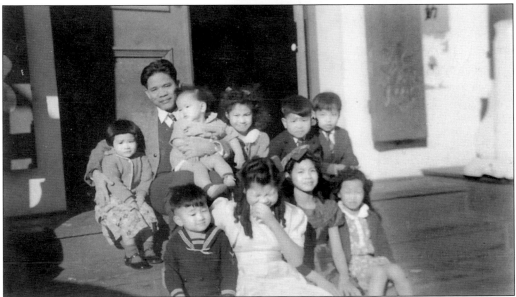

This is a picture of Lip Kee Huie in 1940 with the Hom/Tom family children on the steps of the Bok Kai Temple. Lip Kee was the nephew of Hom Kun Foo. From left to right are (first row) Lawrence Tom, Connie Tom, May Tom, and Helen Tom; (second row) Margaret Tom, Lip Kee, Wilbur Tom, Irene Tom, Arthur Tom Jr., and Leonard Hom. (Courtesy Chinese American Museum of Northern California.)

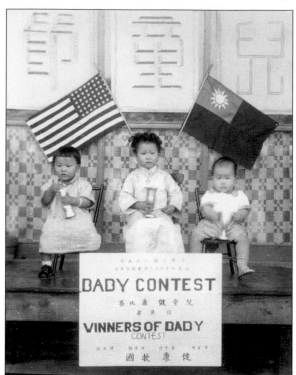

This is a picture of the winners of a baby contest in the Marysville Chinatown. The two known winners are Emily Chin (left) and Arthur Tom Jr. (right). The contest was held in 1936. (Courtesy Chinese American Museum of Northern California.)

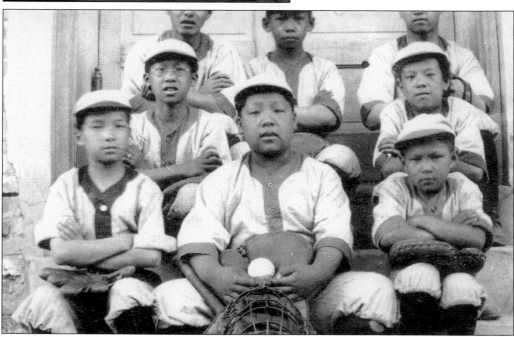

The Marysville Chinatown had an organized children's baseball team in the early 1920s. Among the players are brothers Ernest Yee (first row center), Samuel Yee (second row left, with glasses), and Albert Yee (second row right). Later when the brothers were attending high school, they starred on the 1929 Marysville High School baseball team with Albert as the catcher and Ernest as the second baseman. (Courtesy Brenda Wong.)

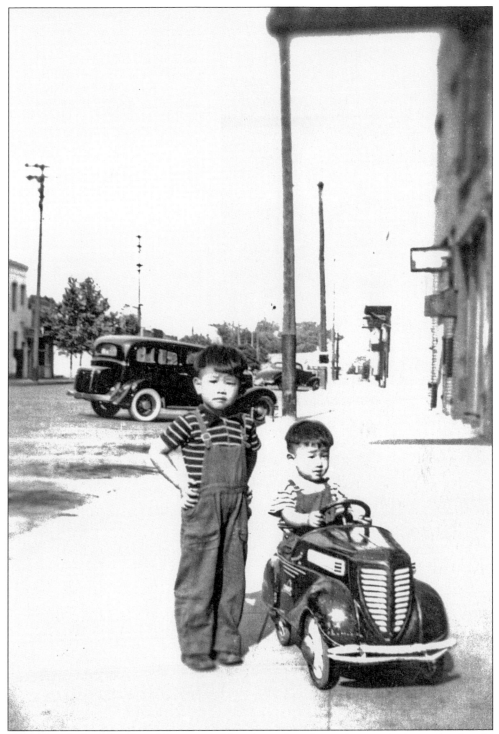

Arthur Tom Jr. (standing) and Lawrence Tom (seated in the car) are enjoying a Sunday drive in their new car in front of 310 First Street in 1939. (Courtesy Chinese American Museum of Northern California.)

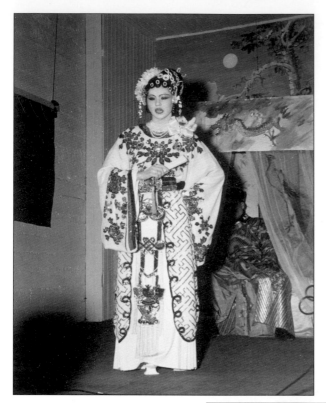

Evelyn Jeong, born in 1929, was the youngest daughter of Hom K. You of Marysville. As a professional Chinese opera singer, she performed with an opera troupe in San Francisco as well as at many Bomb Day celebrations in Marysville in the 1940s. (Courtesy Rogena Hoyer.)

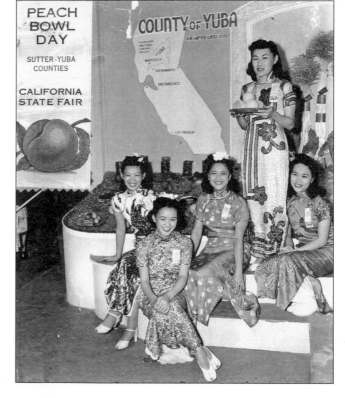

Each year, the County of Yuba sponsors an exhibit in the counties displays at the California State Fair. Assisting with the exhibits during the 1940 state fair are, from left to right, Helen Jang, Bertha Waugh, Pearl Lim, Virginia Waugh Yee, and Alice Hom. (Courtesy Bertha Waugh Chan.)

Eight

DREAMING THE CHINESE AMERICAN DREAM

The Chinese American dream has always been a dream about China and America. In China, they wanted a modern nation free from the unequal treaties imposed upon it by the Western powers and Japan. In America, they wanted equality and the removal of all the racist laws at the federal, state, and local levels that made it impossible to pursue happiness in America. After almost a century of living under racist laws in the greatest democracy in the world, their chance would come with the changes wrought by World War II. When Japan attacked Pearl Harbor in December 1941, many Chinese Americans from Marysville volunteered for the armed services.

In 1939, the Chinese in California had an opportunity to change their negative image created by biased newspaper reporting. A world's fair would take place on Treasure Island in San Francisco, and a Chinese village of one city block was planned where Chinese Americans could present their vision of an idealized Chinese world. The Chinese in Marysville responded. Ong Tall built a Chinese-styled building that housed a gift shop. Other Marysville residents, like Sammy Yee, also participated in the fair by opening restaurants. The Chinese village was a great success as it presented a new vision of Chinese America to visitors who had been prejudiced by the stereotype of the San Francisco Chinatown as a ghetto of gambling halls, opium dens, and brothels.

The ending of the World War II was a time for great rejoicing in Chinese America. The Chinese in Marysville planned to celebrate in style. In 1947, they hosted one of the largest ever Bok Kai Festivals. Chinatown had much to be thankful for: the defeat of Japan, the return of their young men from war, the new job opportunities that seemed to appear everywhere, and the hope that finally they would be treated as equals in America. The Bok Kai Festival that year included a festival queen contest with a formal dance. In addition, they hosted a basketball tournament. A post of the American Legion for Chinese had been opened in Marysville, and they joined in the festivities. Visitors were invited from throughout California. There was a huge display of American flags. The American dream was coming true for Chinese Americans.

The first step in realizing the Chinese American dream was the completion of high school. In the picture are, from left to right: Mabel Lim, May Tom, Charlie Lim, Ella Kim, and Virginia Ong on graduation day in 1947. Mabel was the Marysville High School valedictorian that year. (Courtesy Virginia Ong Tong.)

Yuba College, founded in 1927, was one of the earlier community colleges in the state. Standing by the main entrance to Yuba College are, from left to right: Bill Lim, Henry Kim, Danny Kim, and David Wing. This picture was taken in 1947, the year David Wing graduated from Yuba College. (Courtesy Gene Sing Lim.)

Ong Tall (left) is pictured with Gen. Tsai Tin Tsai, a fellow Cantonese and the commander in charge of the 19th Route Army, which put up a fierce resistance against Japanese invaders of China in the Shanghai War of 1932. He visited Marysville in 1934 on a goodwill mission and was given a hero's welcome. (Courtesy Virginia Ong Gee.)

To help in China's war effort, a huge supply of surgical bandages was prepared and donated by the women's division of the Marysville Chinese War Relief Association in 1939. The work was done at the Presbyterian Chinese Mission. Participating in this effort were Mrs. Gar Yee, Mrs. Lung Kim, Mrs. Yee Kay, Mrs. Wong Guey, Mrs. Chin Yuk, Mrs. Lim Foo, Mrs. Suey Tom, Mrs. Arthur Tom Sr., and Mrs. Ong Tall. Mrs. Ruby Kim Tape was the head of the organization. (Courtesy of Chinese American Museum of Northern California.)

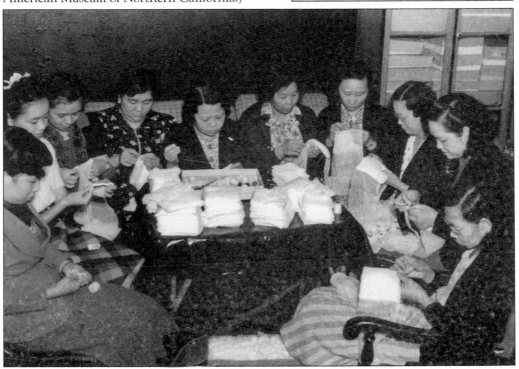

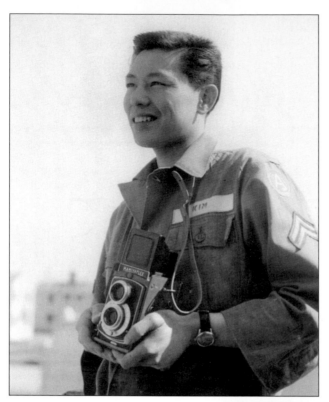

Frank Kim was born at 228 First Street in 1931. He volunteered for the army, and after his discharge in 1954, he attended the University of California, Hastings, College of Law. He was appointed by Gov. Ronald Reagan in 1971 as Stockton Municipal Court judge. Eight years later, in February 1979, Judge Kim was elevated to the superior court by Gov. Edmund G. Brown Jr. (Courtesy Frank Kim.)

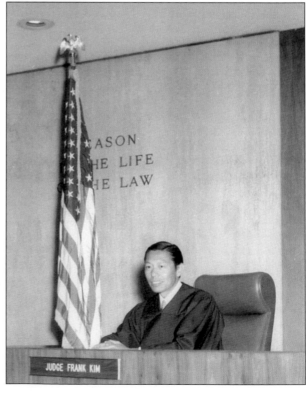

Benjamin Tom was born at 310 First Street in 1926. He is a graduate of the University of California, Berkeley. He was the first Chinese American to be elected to the San Francisco Board of Education in the 1970s and later became the board's president. In the picture, he is being congratulated by Gov. Edmund Brown Jr. (Courtesy Gordon Tom.)

Dr. Hom

$$E = mc^2$$

Leonard Hom was born in 1932 at 310 First Street. He was valedictorian of his 1950 graduating class at Marysville High School. He received his Ph.D. in environmental engineering at the University of California, Berkeley. While at the California Department of Public Health, he developed a water disinfection model that is still in use today. He started his teaching career at California State University, Sacramento, in 1963 and retired as professor of civil and environmental engineering in 1997. (Courtesy of Leonard Hom.)

There were many Chinese Americans who participated in the Marysville High School band. The three shown here in 1944 are, from left to right, Gene Sing Lim, Dave Wing, and Danny Kim in the dress uniform of the Marysville High School Band. (Courtesy Jack Kim.)

The Lim brothers, James and Gene Sing, lived at 232 First Street. Gene Sing, in the army uniform, was in an army artillery unit in 1945. (Courtesy Gene Sing Lim.)

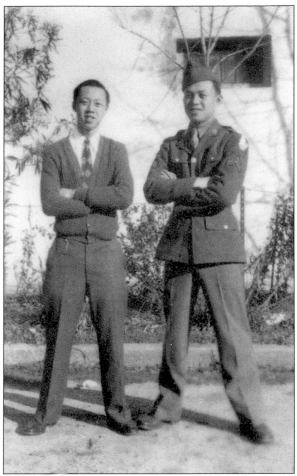

Stanley Hom was born in 1926 in Marysville. He received his bachelor's degree in engineering from the University of California, Berkeley, in 1949. He was in the army from 1952 to 1954 and worked as an engineer with Honeywell Corporation for 30 years before retiring. (Courtesy Stanley Hom.)

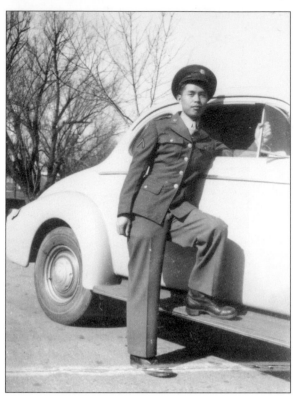

Bing Ong came to America in 1938 at the age of 14. He joined the U.S. Air Force during World War II. His entrance exam grades for a mechanic's position were so high that he was asked to be an instructor, but he declined because he didn't feel his English was up to the task. He worked on the B24 bomber, the Liberator. (Courtesy Bing Ong.)

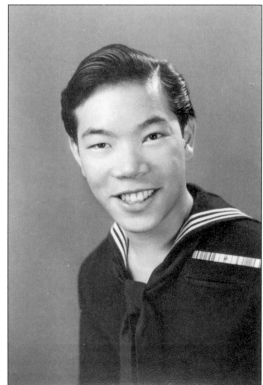

Danny Kim was born in Marysville at 228 First Street. This is a picture of him in his navy uniform during World War II. (Courtesy Jack Kim.)

98

David Wing served at Camp Wolters Army Infantry Training Center in 1945. He graduated with a bachelor of arts in physiology from University of California, Berkeley, in 1950. He was licensed as both a bioanalyst and a clinical pathologist and was the regional laboratory operations manager at Kaiser before retiring in 1992. (Courtesy Jack Kim.)

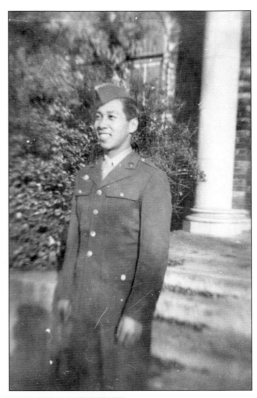

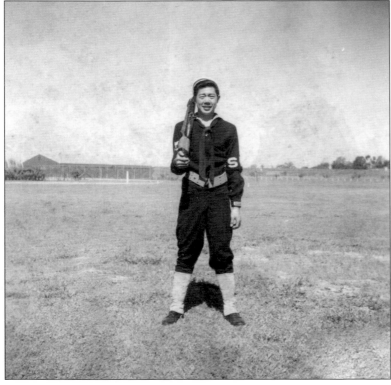

Johnny Yee was in the navy during World War II. His parents owned the Yee Kay Restaurant on 308 First Street. This picture was taken in 1944. (Courtesy Bing Ong.)

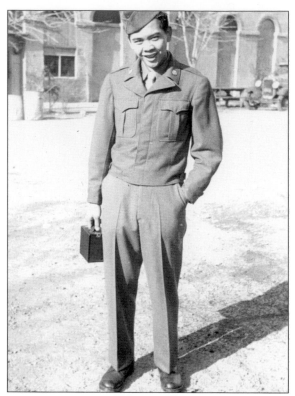

Howard Tom was in the army during the Korean War. His parents owned the T&M Market at 314 Second Street. (Courtesy Gene Sing Lim.)

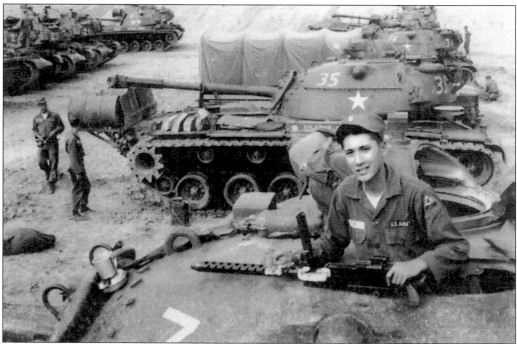

Gordon Tom joined the army in 1958. He served in Germany in the special tank unit with the M103. He was with the 4th Armored Division in Germany. He grew up in the Tung Wo building at 310 First Street. This picture was taken in 1959. (Courtesy Gordon Tom.)

Ruby Kim Tape was born in Marysville and lived at 228 First Street. Her father was Kim Wing, who started the store at that location. She was an activist and headed many charitable functions for the Chinese community. She enlisted into the Women's Army Corps during World War II. (Courtesy Jack Kim.)

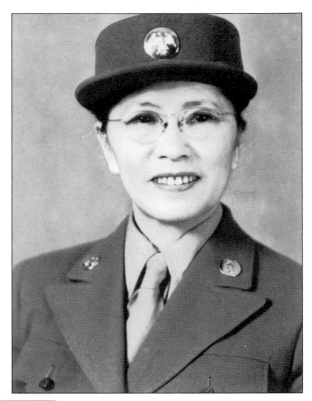

Jack Kim was the first Chinese baby to be born in the Marysville Hospital in 1917. He enlisted in the army at the beginning of World War II and fought in Europe at the Battle of the Bulge. After the war, he continued his education under the GI Bill and became an optometrist. (Courtesy Jack Kim.)

This is a picture of Eugene Dong (left) and Collin Dong (right) when they enlisted in the military service in 1921. After discharge from the service, both of them continued their education and became physicians. Rosie Chin is between the two of them. (Courtesy Brenda Wong.)

Ken Ang always had a love for broadcasting and radios. To pursue his passion, he opened Ken's Radio Store in the early 1950s at 119 C Street next to the Marysville Garage in Chinatown. (Courtesy Virginia Ong Gee.)

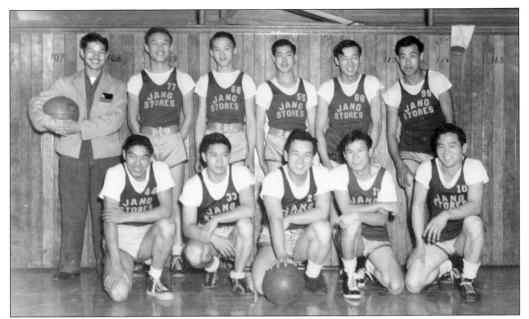

The basketball team was sponsored in the early 1940s by Woodrow Jang, the owner of Jay's department store at 520 D Street. Jack Kim was the team coach. On the team, in the front row are, Charlie Lim (center) and Bobbie Leong (second from right). In the back row, from left to right, are: Jack Kim, Gene Sing Lim, Gene Wong Lim, and Johnny Yee. Some of the teams they played against were Walnut Grove, Isleton, and the Sacramento Fongs. (Courtesy Jack Kim.)

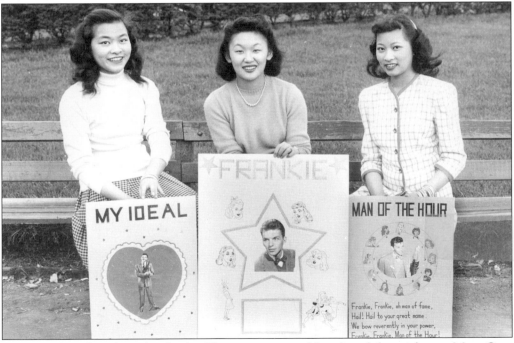

It wasn't all work and no play for the Chinese teenagers. Here from left to right, are Mary Ong, Doreen Foo, and Virginia Ong just having fun in high school. The picture was taken in the 1940s. (Courtesy Virginia Ong Gee.)

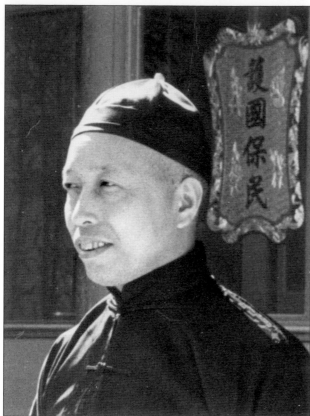

Ong Tall opened the Lotus Inn, a Chinese restaurant at 315 Second Street in 1947. The restaurant was not only popular with the local residents but with many movie stars, such as Bing Crosby, Roy Rogers, and Robert Stack, when they visited Marysville. The building was demolished in 1976 for redevelopment. (Courtesy Virginia Ong Gee.)

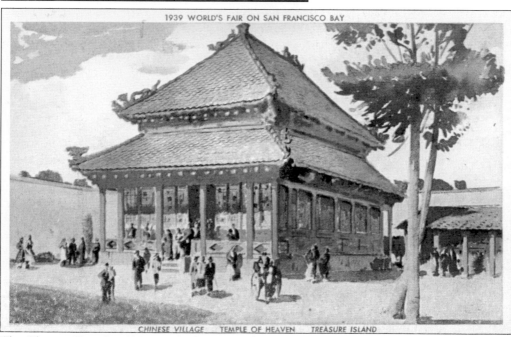

The Chinese Temple of Heaven building was design and constructed by Ong Tall for the 1939 World's Fair held on Treasure Island in the San Francisco Bay. (Courtesy Virginia Ong Gee.)

Nine

A New
Chinese American
Community Emerges

For decades, the businessmen in Chinatown planned for the day when they could expand their businesses into the main part of town and become a part of the general commercial life of the north valley. The end of the war provided an opportunity; for the first time, Chinese American businessmen opened stores outside Chinatown. Not only were they able to leave Chinatown, but they went into businesses that were different than the traditional restaurants and laundries. Suddenly they could compete in the general economy for European Americans customers. Marysville Furniture Store, Savemor Department Stores, Jay's, Yuba Market, Eagle Gas Station—all these businesses were started during this period. These new businesses had a tremendous impact on the Chinese families in Marysville, allowing many to enter into the mainstream of American life.

A sense of normalcy spread inside the Chinese community. In 1953, the first Chinese American family moved to East Marysville, a heretofore exclusively European American suburban part of town. Other Chinese American families followed. The postwar American dream of a suburban lifestyle with lawns, televisions sets, broad streets, and new schools became available for many Chinese in Marysville. The crowded ghetto life of Chinatown began to recede into the past.

With the new changes, there grew a need to create a new Chinese American community. The Twin Cities Chinese American Club was formed to meet that need. For the first time, a Chinese organization was formed that was not centered in Chinatown and did not conduct their meetings in Chinese. Many of the members were part of the new professional class of doctors, managers, business owners, and civil servants. The activities the club engaged in were primarily social. Instead of holding meetings in an association hall, the Twin Cities Chinese American Club held their meetings in their members' homes.

At the same time, the Twin Cities Chinese American Club maintained their ties to the traditional Chinatown celebrations, including Bomb Day. Every year, they sponsored a float during the Bok Kai parade. A new generation of Chinese Americans was emerging, more educated and more integrated into the general society.

The fourth Marysville Chinatown Reunion was held in San Mateo, California, in May 1991. The reunion was organized by the Chinese who were born in the 1920s and 1930s and lived together in

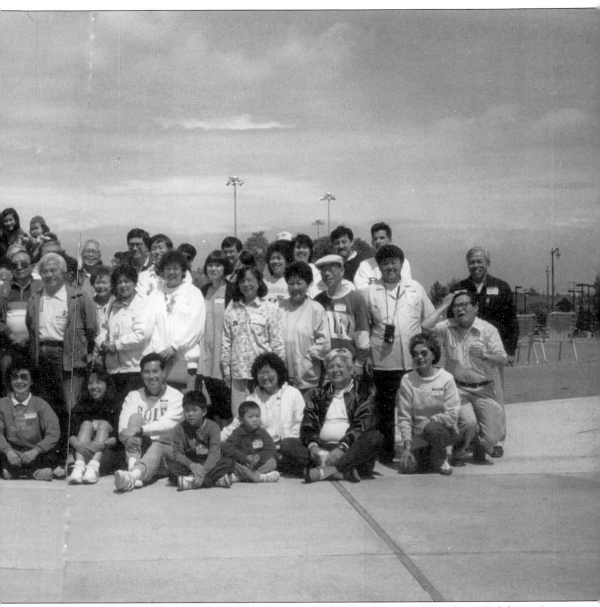

Chinatown during that time. (Courtesy Chinese American Museum of Northern California.)

5th MARYSVILLE REUNION

Saturday, June 6, 1998
at SUEY SING BUILDING
First & "C" Street
Marysville, California

Come bring your scrapbooks and pictures and share in a day of fun. Family and friends are welcome!

Doors open at 1:00 p.m. and a delectable steak dinner will be served at 4:00 p.m.

Adults • $12.50 Ages 7-16 • $5.00 Ages 6 & Under • FREE

The committee is happy to announce that $500 from our 4th Reunion picnic was donated to the BOK KAI Restoration Fund toward the repair of the roof of the temple. OUR THANKS TO EACH AND EVERYONE OF YOU!

To attend, please fill out the registration form below and return with your check by **May 16, 1998,** payable to: GENE SING LIM
4030 Soelro Court
San Jose, CA 95127
(408) 258-7738

HOPE TO SEE YOU THERE!

This is the announcement for the fifth Marysville Chinatown Reunion, held at the Suey Sing Association Building at First and C Streets in June 1998. (Courtesy Chinese American Museum of Northern California.)

At the fifth reunion, some of the participants attending were, from left to right, (first row) David Wing, unidentified, Gene Sing Lim, Charlie Lim, Robert Lim, Stanley Hom, and Robert Yee; (second row) Leonard Hom, Lawrence Tom, Jack Lee, Ben Tom, and Arthur ("Bobo") Yee. (Courtesy Chinese American Museum of Northern California.)

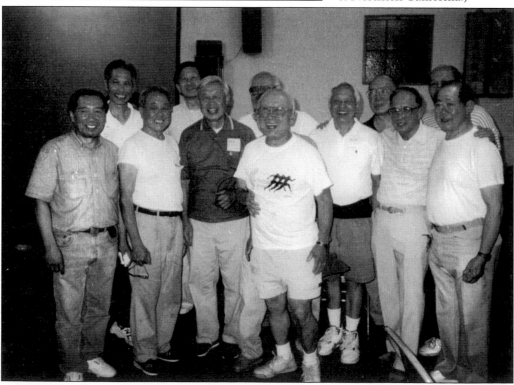

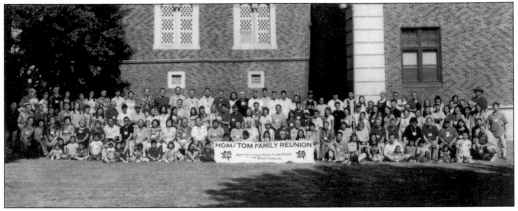

The Hom/Tom families of 310 First Street had a family reunion in Marysville on May 14, 2005. This reunion was for the descendants of Hom Kun Foo and Lee Shee. There were 163 people in attendance. Herbert Gee was recognized as the oldest family member at the age of 93. (Courtesy Chinese American Museum of Northern California.)

The Twin Cities Chinese Club was established in 1956. The organization was a social one that promoted friendship between the Chinese in the communities of Marysville and Yuba City. In this mid-1960s picture, in the front row from left to right, are Jack Gee, Bill Suey, and Charlie Lim. In the back row, from left to right, are Virginia Gee, Rose Fong, unidentified, and Gene Fong. (Courtesy of Gordon Tom.)

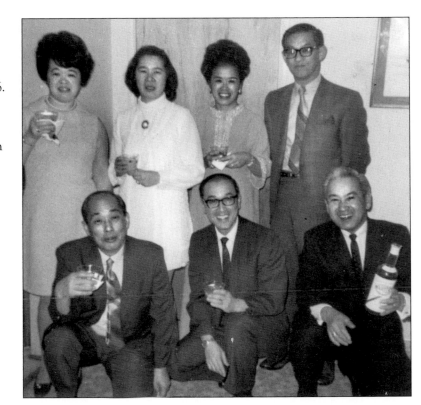

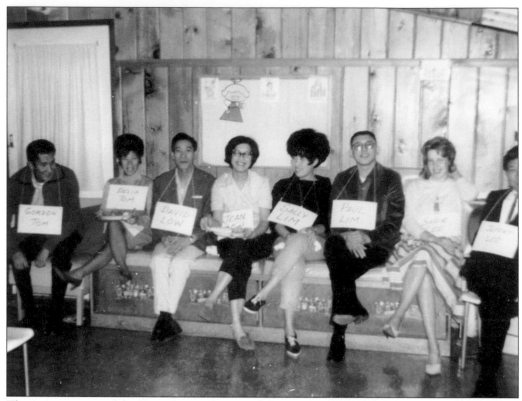

These pictures are of the Twin Cities Chinese Club initiating new members into the organization in 1963. The new members (above) are, from left to right, Gordon Tom, Delia Tom, David Low, Jean Low, Sally Lim, Paul Lim, Susie Lee, and Jeffery Lee. (Courtesy of Gordon Tom.)

The Twin Cities Chinese Club held its annual Halloween party for children in 1964. Prentice Tom is among the children in the picture. In 2000, he was appointed as the chief medical officer for the California Medical Group (CEP), one of the largest medicine emergency groups in the United States. (Courtesy Gordon Tom.)

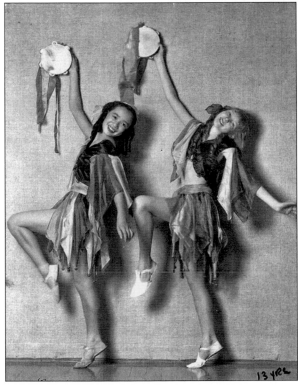

Bertha Waugh studied dancing at the Gracer Dance Studio in Marysville from 1924 to 1938. On the left is Bertha at the age of 13 with a friend performing at the studio in 1937. (Courtesy Bertha Waugh Chan.)

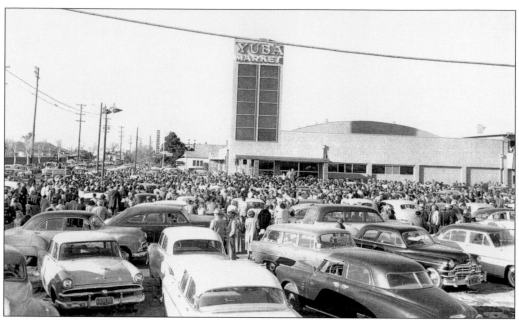

In 1939, the first Yuba Market was located at 520 Third Street and was known as the New Yuba Grocery. The manager was Lee Shew Wing. The business had nine partners. Yuba Grocery subsequently moved to Twelfth and B Streets, had a grand opening in 1955, and changed its name to Yuba Market. It was the largest supermarket in Marysville at that time and was managed by Leland Lee from Colusa. (Courtesy Gordon Tom.)

The Marysville Furniture Store was located on Third and C Streets in the building occupied by the U.S. Hotel. Arthur Tom Sr. started the business in 1948. It was the largest furniture store in Marysville at that time. (Courtesy Bing Ong.)

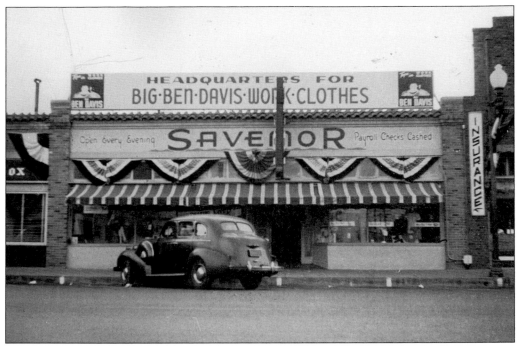

The first Savemor department store was opened in Yuba City in 1946 by Arthur Tom Sr. It was the first and largest department store on Plumas Street. The company expanded and added two additional stores, one in Marysville and another one in Gridley. (Courtesy Arthur Tom Jr.)

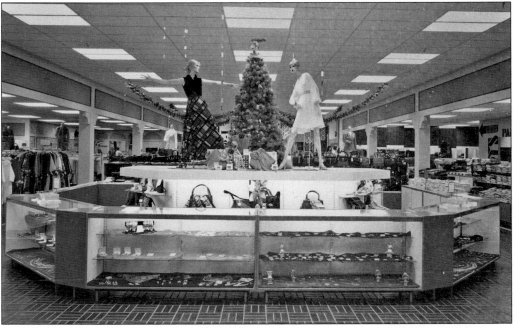

The Savemor department store was renamed Sherwood department store in 1961 by Arthur Tom Jr. The name was later changed again to Arthur's department store in 1964. This 1972 picture is the front counter of Arthur's department store, opened at the mall in Marysville. (Courtesy Arthur Tom Jr.)

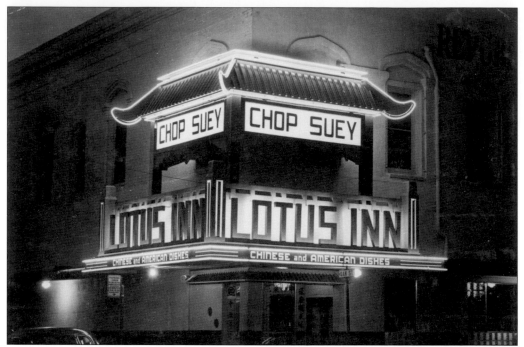

Lotus Inn, opened by the Ong family in 1947, was an immediate success. Though the restaurant operations just broke even, the bar did very well and received an award in 1968 from Seagram's for selling 2,500 cases of their liquor. (Courtesy Virginia Ong Gee.)

A gathering of local dignitaries inside the bar of the Lotus Inn restaurant was not uncommon. Large groups of people after business hours would mingle together, or special occasions were celebrated at the bar. Fred Ong is shown here in 1947 greeting guests. (Courtesy Virginia Ong Gee.)

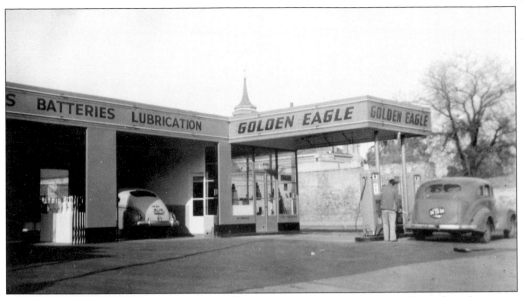

The Golden Eagle Gas Station was purchased by Arthur Tom Sr. in 1948. It was located on the corner of Seventh and B Streets. (Courtesy Chinese American Museum of Northern California.)

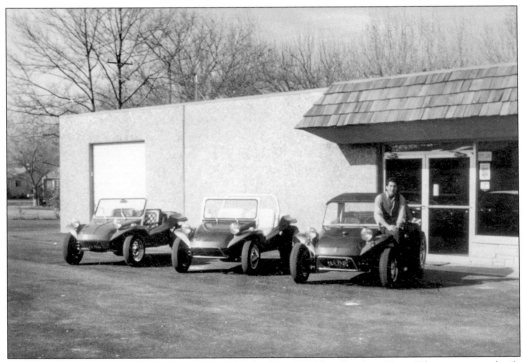

Golden T Automotive Company was established in 1966 by Gordon Tom. The company built off-road vehicles from 1966 to 1969. His first vehicle, the GT Rhino, was sold to the movie star and singer Bing Crosby. (Courtesy Gordon Tom.)

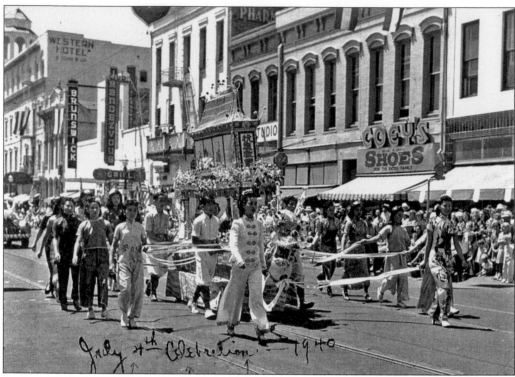

In the 1940 Fourth of July parade in Marysville, the Chinese community participated in the event with a float. The three girls in the front of the float are from left to right Clara Waugh, Bertha Waugh, and Helen Jang. (Courtesy Bertha Waugh Chan.)

The Golden Pheasant Restaurant at 219 D Street was owned by the Gene Wong family during the 1950s. (Courtesy Bing Ong.)

Five of the buildings in this picture have been demolished for redevelopment. Those at 310 and 312 First Street are the only remaining buildings in Chinatown on the south side of First Street between C and Oak Streets. The building at 310 First Street was the Hom/Tom family home for over 100 years. (Courtesy Gordon Tom.)

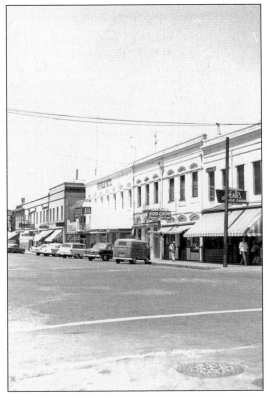

The Royal Café was owned by Lim Tong Foo at 307 Second Street in the 1940s. The name of the restaurant was later changed to the Soo Chow. (Courtesy Bing Ong.)

昆利允 MARYSVILLE, CALIF.

華僑救國會	Chinese Relief Ass'n, 102 C St., Tel. 110
中國國民黨	Kuo Min Tang, 230 1st St.
洪門致公黨	Chee Kung Tang, 211 1st St.
萃勝工商會	Suey Sing Ass'n, 305 1st St., Tel. 110
合勝堂	Hop Sing Ass'n, 113½ C St.
中華學校	Chinese School, 226 1st St.
忠義堂	Chung Yee Tong, 16 C St.

★ 餐 館 ★

藍雀餐館	Blue Bird Cafe, 222 C St., Tel. 1221
龍子餐館	Dragon Seed Cafe, 219 D St., Tel. 1601
哈利榮餐館	Harry Wing Chop Suey, 123 D St., Tel. 1121
杏香樓林舉文	Hing Hong Low, 103 C St., Tel. 106
瓊園 鄧粵貽	King inn, 101 C St., Tel. 1278
林佐治餐館	Lim Geo. Cafe, 123 C St., Tel. 1158
新中國樓鄧操	New China Cafe, 212 C St., Tel. 446
新居飯店	New Home Cafe, 129 Oak St., Tel. 2288-W
萊路餐館	Royal Rest., 307 2nd St., Tel. 1446
勝利餐館	Victory Cafe, 203 C St.
余祺餐館	Yee Kee Chop Suey, 308 1st St.

★ 商 店 ★

巴黎肉店	Paris Meat Market, 313 E St., Tel. 1608
紐優巴孖結	New Yuba Meat Market, 520 3rd St., Tel. 871
譚春孖結	T & M Market, 314 2nd St., Tel. 91
聯合孖結	Union Market, 300 2nd St., Tel. 1382
中興公司	National Dollar Stores, 424 D St., Tel. 2263
首都商店	Capital Dollar Store, 208 D St., Tel. 1566-W
譚新和理髮店	Sun Wo Barber Shop, 311 1st St.
昌和 陳富明	Chong Wo, 102 C St., Tel. 110
錦榮 周龍錦	Kim Wing Co., 228 1st St., Tel. 2278
昆明	Kun Ming Co., 118 C St., Tel. 2198
耀記	Lim's Co., 112 C St., Tel. 1563
美華	Mee Wah Co., 106 C St., Tel. 1332
南京	Nanking Co., 316 2nd St., Tel. 1637
廣發	Quong Fat Co., 124 C St.
上海	Shanghai Co., 306 2nd St.
成利	Sing Lee, 308 1st St.
新世界	Sun Sei Kei, 303 1st St.
日光	Sunshine Co., 127 Oak St., Tel. 1617
祥和 譚廸聖	Tung Wo, 310 1st St., Tel. 1123
迎賓	Ying Bun Co., 307 1st St.

This is a listing of the Marysville Chinese organizations and businesses in Chinatown from the 1946 Handbook of Chinese in America. (Courtesy Chinese American Museum of Northern California.)

2008

Ten

THE LAST CHINATOWN OF GOLD RUSH CALIFORNIA

The Marysville Chinatown is the last Chinatown of Gold Rush California. The Chinese built over 30 Chinatowns in California during the Gold Rush. The ones in the southern mines were the first to go. Angels Camp, San Andreas, Chinese Camp, Fiddletown, Plymouth, Mokelumne Hill, Coloma, Columbia, and many more towns had Chinatowns. But when the gold gave out, the Chinese moved to valley towns or San Francisco. Today the only evidence remaining of the pioneering work of the Chinese Americans in these towns is usually a short reference to them in a local museum or artifacts in a showcase in an antique store.

The northern Chinatowns lasted much longer. There many of the Chinatowns were able to maintain viability as the local economy changed to agriculture or hard rock mining. These Chinatowns met a different fate. Their demise was more likely caused by the extremists of the anti-Chinese movement.

Through the turmoil that afflicted the other Chinatowns, the Marysville Chinatown remained a vibrant and cohesive community through the 1960s. Then slowly the Chinatown changed as many families moved across the river to Yuba City and young people left for college and never returned. Later redevelopment came to the Marysville Chinatown, and many of the old buildings were demolished.

Following the example set by their pioneer forebears, the Marysville Chinese never surrendered. They still worship at the Bok Kai Temple and celebrate Bomb Day just as their ancestors did 150 years ago.

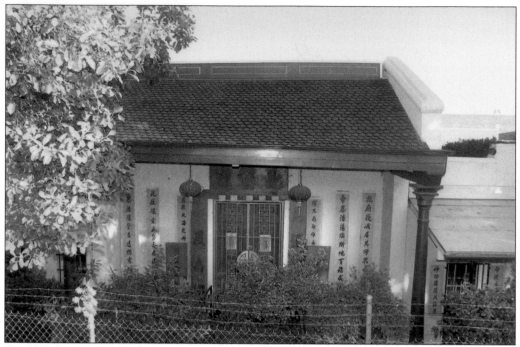

The Bok Kai Temple is shown here in the year 2007. On Bomb Day, as soon as the doors are opened to the temple, a large crowd of worshippers lined up to enter the temple and make offerings to the gods. (Courtesy Chinese American Museum of Northern California.)

During the Bomb Day celebration, fortune tellers are available at the Bok Kai Temple. In Chinese society, fortune telling is a respected and important part of social and business culture. Here the fortune teller is describing his thoughts to his clients. (Courtesy Frank Jang.)

One of the unique characteristics of the Bok Kai Temple is the mural that depicts vivid scenes of Chinese culture. The painting extends across the upper wall of the outside front entrance to the temple's altar room. (Courtesy Frank Jang.)

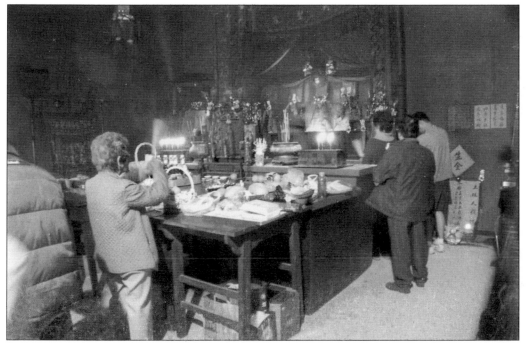

This is the temple's main altar hall used for worship. During the Bomb Day celebration, there is a large crowd of worshippers inside providing offerings to the gods. (Courtesy Frank Jang.)

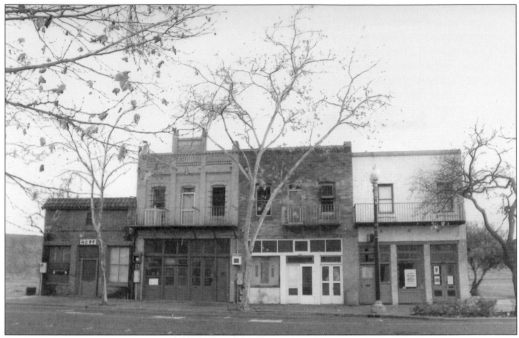

These are the four remaining buildings on the south side of First Street between Elm and C Streets. The Chinese School is 226, the Kim Wing building is 228, the Kuo Ming Tang building is 230, and the Chinese American Museum of Northern California is 232. (Courtesy Chinese American Museum of Northern California.)

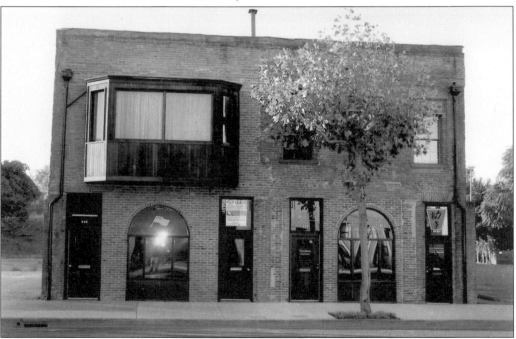

These are the two remaining building on the south side on First Street between C and Oak Streets. These are 310 and 312 First Street. These were built in 1853 and retrofitted to earthquake standards in 1980s. (Courtesy Chinese American Museum of Northern California.)

GRAND OPENING

THE CHINESE AMERICAN MUSEUM OF NORTHERN CALIFORNIA

MARCH 24 & 25, 2007
10 AM – 5 PM
BOK KAI FESTIVAL (Bomb Day)
232 1st STREET
MARYSVILLE, CALIFORNIA

SPECIAL EXHIBITION:
The Lost Chinatowns of Old California - Ghost Towns and Survivors

Permanent Exhibitions:
Marysville—The Last Chinatown of Gold Rush California
Chinese American History in 10 (Easy) Steps
Defining the Chinese American Dream
The Sanfow Bean Sprout Plant

Beginning April, 2007, the Museum will be open
on the 1st Saturday of each month from 12 noon to 4 p.m.

Grand Opening Schedule, 10 AM – 5 PM

Saturday, March 24, 2007

1:15 p.m.	**Remembering Chinatown**, a walking tour with **Lawrence Tom**
2 p.m.	**Reception**. Museum, 2nd Floor
2:30 p.m.	**Introduction to the Museum: Brian Tom.** Museum, 2nd Floor
3 p.m.	**Critique of Chinese American History in 10 (Easy) Steps - Gordon Chang, Ling-chi Wang, Judy Yung**. Museum, 2nd Floor
4 p.m.	**The Chinese Gods of Marysville - Jonathan Lee**. Museum, Temple Display.
6 p.m.	**Award Dinner**, limited tickets ($10 at Museum): Szechwan Restaurant, Marysville

Sunday, March 25, 2007

2 p.m.	**Defining the Chinese American Dream: Gordon Chang, Gregory Mark, Judy Yung**. Museum, 2nd Floor
2:45 p.m.	**Great Grandfather Hom Hock Fun, a Marysville Pioneer – Encountering His Memory, Gordon Chang.** Museum, 2nd Floor
3 p.m.	**Chinatown Memories: Frank Kim, Emily Yue. Arthur Tom**, Moderator. Museum, 2nd Floor
4 p.m.	The Firing of the Bombs by the Marysville Chinese Community

Asian American Curriculum Project will have available for sale, books of Chinese American interest.

The Chinese American Museum of Northern California
232 1st Street, Marysville, CA 95901

The Chinese American Museum of Northern California in Marysville had its grand opening on March 24 and 25, 2007. The objective of the museum is to preserve and interpret the history of the Chinese in America. Since its opening, the museum has served as a gathering place for residents and former residents who want to share memories of the old days. The museum has also served as a repository for those who wish to donate Chinese American artifacts. (Courtesy Chinese American Museum of Northern California.)

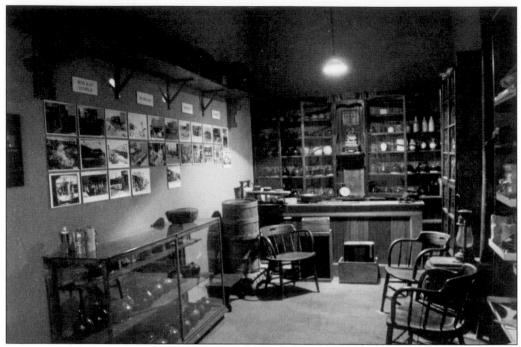

The front room of the museum is a replica of an old Chinese store during the late 1800s. The room has a potbellied stove and chairs similar to stores from that era. (Courtesy Chinese American Museum of Northern California.)

This is the rear room of the museum. It has been restored to its original state as a bean sprout plant. Bean sprouts grown here were supplied to the Chinese restaurants in Marysville and surrounding communities. It was operated by the Lim Foo family for many years. (Courtesy of the Chinese American Museum of Northern California.)

Brian Tom, director of the Chinese American Museum of Northern California, in the 2007 museum program is introducing Gordon Chang, professor of American history at Stanford, and Judy Yung, professor emeritus University of California, Santa Cruz. They are speaking on the Defining the Chinese American Dream panel. (Courtesy Frank Jang.)

The museum's 2007 program culminated in the evening with the first annual Pioneer Award dinner at the Szechwan Restaurant. The Pioneer Award was presented to Lillian Gong-Guy and Gerrye Wong for their contributions to the preservation and interpretation of the history of the Chinese pioneers in America. They are the cofounders of the Chinese Historical and Cultural Project in San Jose. (Courtesy Chinese American Museum of Northern California.)

Lawrence Tom is leading the popular Remembering Chinatown walking tour during the 2008 Bomb Day celebration. He is describing some of the remaining buildings on First and C Streets. The tour is part of the program of the Chinese American Museum of Northern California. (Courtesy Rogena Hoyer.)

The firing of the bombs in 2008 is still similar to the celebration that occurred over 100 years ago on Bomb Day. (Courtesy Frank Jang.)

The 2008 award dinner featured the presentation of the Pioneer Award to Steve Yee, pictured above (holding the award), with some of his supporters. Steve is the chair of the Friends of the Yeefow Museum and has led the effort to reclaim the history of the Chinese in Sacramento through the creation of a new museum. (Courtesy Frank Jang.)

The 2008 program had a special performance from the Grant Avenue Follies of San Francisco. They are former Chinatown nightclub dancers from the 1950s and 1960s who reunited to bring back the glory days of Chinatown entertainment. (Courtesy Frank Jang.)

Across America, People are Discovering Something Wonderful. Their Heritage.

Arcadia Publishing is the leading local history publisher in the United States. With more than 4,000 titles in print and hundreds of new titles released every year, Arcadia has extensive specialized experience chronicling the history of communities and celebrating America's hidden stories, bringing to life the people, places, and events from the past. To discover the history of other communities across the nation, please visit:

www.arcadiapublishing.com

Customized search tools allow you to find regional history books about the town where you grew up, the cities where your friends and family live, the town where your parents met, or even that retirement spot you've been dreaming about.